Pioneer Quilts

Prairie Settlers' Life in Fabric

Over 30 Quilts from the Poos Collection • 5 Projects

Lori Lee Triplett and Kay Triplett

C&T PUBLISHING

Text copyright © 2017 by Lori Lee Triplett and Kay Triplett

Photography and artwork copyright © 2017 by C&T Publishing, Inc.

Publisher: Amy Marson

Creative Director: Gailen Runge

Editor: Liz Aneloski

Technical Editors: Deanna Csomo McCool, Sadhana Wray, and Linda Johnson

Cover/Book Designer: April Mostek

Production Coordinator: Zinnia Heinzmann

Production Editor: Jennifer Warren

Illustrator: Tim Manibusan

Photo Assistants: Carly Jean Marin and Mai Yong Vang

Photography by Diane Pedersen of C&T Publishing, Inc., unless otherwise noted

Published by C&T Publishing, Inc., P.O. Box 1456, Lafayette, CA 94549

Library of Congress Cataloging-in-Publication Data

Names: Triplett, Lori Lee, 1960- author. | Triplett, Kay, 1957- author.

Title: Pioneer quilts : prairie settlers' life in fabric - over 30 quilts from the Poos collection - 5 projects / Lori Lee Triplett and Kay Triplett.

Description: Lafayette, California : C&T Publishing, Inc., [2017] | Includes bibliographical references.

Identifiers: LCCN 2016050619 | ISBN 9781617454653 (soft cover)

Subjects: LCSH: Quilting--Patterns. | Pioneers in art. | Quilts--Private collections--Kansas.

Classification: LCC TT835 .T765 2017 | DDC 746.46--dc23

LC record available at https://lccn.loc.gov/2016050619

Printed in the USA

10 9 8 7 6 5 4 3 2 1

Dedication

To the pioneers, who blazed a trail for us to follow, wrote journals or diaries for us to explore, and left textiles as a legacy of artistry for us to love.

Acknowledgments

Thank you to everyone who continues to support our quilting journey.

According to historian Merrill Mattes, pioneers may be divided into three main categories: soldiers who occupied the military posts and conducted government business;[5] civilians who made a living in the wilderness—trappers, traders, teamsters, laundresses, cooks, stagecoach drivers, Pony Express riders, station keepers, mail contractors, and explorers;[6] and immigrants—anyone whose main purpose was to travel to improve his or her fortune.[7]

This is the group of people that we focus on—those mothers, daughters, sons, and fathers who left behind family and friends to travel to a new place and create a home. Myths about the great trek started quickly, with writers who may never have taken the trip creating stories about it. The tall tales have continued, enhanced by Hollywood. Instead of relying on the myths, this book is supported by historical research, records of friends and family who lived during the nineteenth century, and other primary sources. More than 2,000 diaries exist from the period, reproduced faithfully in book collections or published by individuals. Finally, state and local historical societies have among their holdings diaries, letters, and notes.[8]

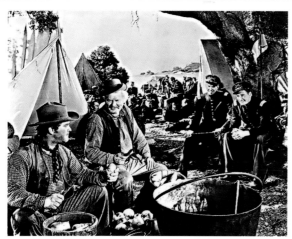

Hollywood's version of the well-equipped, happy pioneers in the movie *Santa Fe Trail*, with Ronald Reagan, Errol Flynn, and Alan Hale Sr.
Photo by Film Archive

Preparation

According to the diaries, pioneers' preparations for the trip tended to follow one of three different philosophies, each with positives and negatives.

In the first group were those who simply chose to sell all their possessions and travel light—usually individual travelers. By taking less, a pioneer could make better time and be less likely to experience a few of the hazards of the trail, such as theft. But travelers taking this approach might not have the supplies needed to survive, because "stores and places to stay" were not available to strangers in the early part of the century.

The second group adopted the opposite extreme, taking every possession and buying more, planning to be prepared for anything. But as wagons broke down or the weight proved to be too much for the livestock hauling it, many of these belongings were simply left by the side of the road. Trading or selling the extra items was rarely successful, because others knew that if there was excess, it would likely be left behind. Anything left by the side of the road could be claimed for free after the owner departed.

The final group were those pioneers who elected to take a minimal number of items but selected those carefully. If available, information from someone who had already made the trek often proved vital. Some diaries and other sources mention the wagon master, a "guidebook," or letters from others who had successfully completed the journey. This group of pioneers appears to have been the most successful in making it to a new place to "improve their fortune."

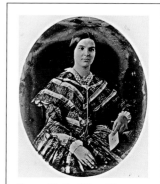

Susan Shelby Magoffin (1827–1855), the wife of a trader, who traveled the Santa Fe Trail in the 1840s and left a diary
Photo courtesy of the State Historical Society of Missouri

These preparations took from many months to up to a year to complete and were frequently difficult. There were wagons, livestock, weapons, and tools to prepare. Pine boards for coffins were also sometimes included in the preparation, because it was considered unlikely that everyone embarking would survive the journey. Fruit and vegetables were dried, and meat was salted. Flax was grown, and cotton was gathered and turned into homespun cloth to make tents, wagon tops, sheets, and death shrouds. Georgia L. McRoberts, whose family moved from Mississippi to the South Platte Valley, wrote about the preparations: "Mother… got cotton and wool which she carded, then spun; dyed and wove yard after yard of sheets, bed spreads, dress goods and even 'jeans' for men's pants."[9]

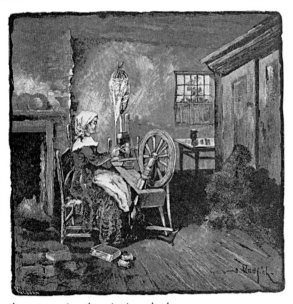

A woman using the spinning wheel
Scanned book illustration courtesy of Internet Archive Book Image

Keturah Belknap wrote, "Will spin mostly evenings while my husband reads to me. The little wheel in the corner don't make any noise. I spin for Mother B and Mrs. Hawley and they will weave; now that it is in the loom I must work almost day and night to get the filling ready to keep the loom busy."[10] After all the preparation came the loading of things to be taken and sorting of what was to be left behind. Besides all

the survival supplies, two books most often made the journey: the Holy Bible and John Bunyan's *Pilgrim's Progress*. Parting gifts included friendship quilts or special quilts made of silk.[11] Then came perhaps the most difficult part—saying goodbye to friends, family, and pets. Keturah Belknap withheld the news of her migration from her parents because she knew she would never see her family again.[12] She was afraid she would break down if she shared the plans with her parents. Welborn Beeson, a fifteen-year-old, wrote of being required to shoot Socrates, his pet cat, rather than "fret" over Socrates not receiving the care he needed.[13]

The Journey

After the preparation, the journey itself would be arduous, because most pioneers walked at a pace of ten to fifteen miles a day. The covered wagons were full of supplies, so unless serving as a driver, the pioneer walked beside the wagon so as not to add to its weight. Horses were a luxury; unless the pioneers were wealthy or the horses were used for work, rarely was a family able to ride horseback.

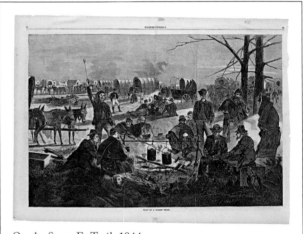

On the Santa Fe Trail, 1844
Scanned book illustration courtesy of Commerce of the Prairies, Josiah Gregg, 1844

Very few primary source records mention the process of quilting during the actual journey, but sewing, patching, mending, stitching, and knitting were mentioned regularly in the sources we read. Even

some spinning on the trail is mentioned—in one case, a spinning wheel was created with a grinding stone on hand.[14] There was so much work to be done every day to simply progress on the journey, let alone to be able to work on a quilt. Also, the light was poor, so knitting was suggested as the best option.

But quilts themselves are mentioned regularly in the primary sources. Since there was no room for beds, some travelers used quilts or comforters on top of feed sacks.[15] Quilts were used to keep the rain out of the wagon and to wear as protection from the elements or from Indians attacking the wagon train. Jane Gould, during an Indian attack, "put up a mattress, and some beds and quilts to protect" herself and others.[16]

Blankets were preferred over quilts by men because, as one man writing back to his wife explained, "Quilts don't answer very well on the road, they get torn too easily."[17]

But the women weren't willing to give up their treasured quilts, except perhaps to honor a loved one's passing. Catherine Haun wrote that "the bodies were wrapped together in a bed comforter and wound quite mummified with a few yards of string" made from a cotton skirt.[18] Babies, sometimes so small, were wrapped in doll-size quilts.[19] The journey was difficult, and deaths were frequent; most journals described deaths and/or seeing graves, with one legend telling of five graves per mile on the Oregon Trail.

Life on the Plains

As the pioneers reached the land of their choice to settle, it quickly became clear that settlement was all about survival. Men and women on the plains were not as restricted by society as their Eastern counterparts. Women held nontraditional roles: postmaster (postmistress) for the U.S. Mail, sharpshooter, reformer, and businesswoman.[20] On the plains, a woman might dig post holes, roof a barn, and plow a field.[21] Whatever needed to be done had to be done by whomever could do it.

But the traditional roles helped open doors for survival on the plains in other ways. The ability to sew and other needlework skills were highly valued on the plains, with women able to earn additional money for their labors. Women were in the minority, and therefore their skills had a higher market value. Women could add to their cash income with their sewing, but they also found that it brought remarkable trading values, being exchanged even for livestock.

Even though every day was about survival, entries about quilts were very apparent. "It was a cold blustery day, but we moved into our new house … we nailed up quilts to make it more comfortable," wrote Chestina Bowker Allen in 1854.[22]

Sewing in a tent by kerosene light

Scanned illustration courtesy of New Colorado and the Santa Fe Trail, Augustus Allen Hayes, 1881

Hannah Anderson Ropes, in letters from 1856, mentions quilts and quiltmaking, as well as the neighbor's quiltmaking scrap bag.[23] The scrap bag is notable, because fabric was very important and expensive on the plains. An average of the fabric prices listed in several diaries in the 1850s demonstrate that, when adjusted for current value, one yard of basic cotton would have cost approximately $45. Even at that cost, quilters carried on; quilting bees, quilting crowds, and so forth are mentioned in documents as early as the 1850s.[24]

Many of the quilt names listed in diaries seem to be original, named after a friend or town.[25] Some of these unique names provide the story of the plains within the name and the quilt. Since patterns weren't readily available, women tried to memorize or make notes about a quilt pattern glimpsed on a neighbor's bed or wall. After hearing about an interesting pattern, some rode over to a nearby town to trace or memorize it. It wasn't until after 1880 that patterns were commonly published, providing more standard names. The publishing of patterns in the 1880s coincided with easier access to fabric. In fact, through mail-order houses, seamstresses could buy fabric scraps specifically for making quilts.[26]

Our Pioneers and Migration

Both of us are products of the Great Plains, and, more specifically, of Kansas. On our mother's side, Samuel Downing Boatwright (our mother's grandfather) came from a line that arrived in Virginia before 1704 and migrated to Indiana and then Iowa before settling in Lancaster, Kansas in 1885. Our great-grandmother, Alice Chapman, arrived in Kansas on a covered wagon in 1879.[27] She grew up in a sod house in Graham County (later Belleville, Kansas), and then, upon her marriage, moved to Lancaster, Kansas.

she lost the use of one arm, but even during those difficult pioneer times, she was able to run a household and raise five children. She also did needlework and quilting by pinning the fabric to her skirt so she could stitch with her good hand. Our mother has a quilt top made by Grandma B with penny squares (redwork) that we've used as a tablecloth, which helped us remember her as well as her story.

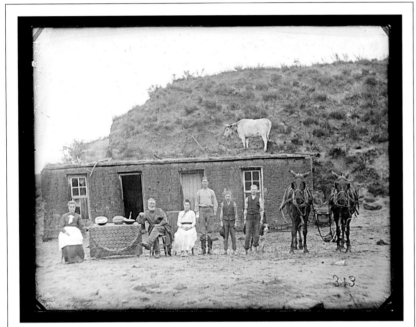

Rawding family sod house
Photo by Solomon D. Butcher (1856–1927)

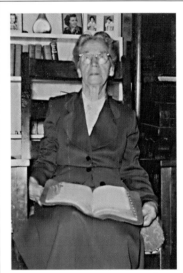

Alice Boatwright ("Grandma B") with her Bible in her favorite chair, surrounded by photos of her descendants
Photo by the Boatwright family

Alice, who was referred to in our family as Grandma B by multiple generations, had polio as a child. Family lore claims that she "rode over on a pillow;" we couldn't, however, find proof of this. Because of the polio,

Martha Boatwright Poos, one of the five children raised by Grandma B, grew up in Lancaster, Kansas. She would marry a recent immigrant to Kansas from Germany, Dr. Henry Poos, a veterinarian. Like other pioneer women before her, she was less defined by "traditional women's roles." On January 31, 1957, she was appointed as U.S. Postmaster, and she ran the post office for the area.[28] When the small town outgrew its one-room schoolhouse, she purchased the place to live in. Eventually she ran the Little Red Schoolhouse Café, which was a counter with a few bar stools where travelers passing through could eat.

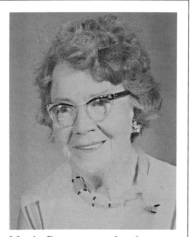

Martha Poos, our grandmother
Photo by the Poos family

Grandma was an avid quilter who made all of her grandchildren a quilt as a high school graduation present. She also taught both of us to quilt. Lori still has her childhood apron that they pieced together out of feed sacks. Kay has multiple quilts made by Martha Poos in the Poos

Collection; however, most of the quilts in the collection were not made or collected by her. Instead, the collection was named to honor our grandmother and was created by Kay over time, through purchases at estate sales, at antique shops, on worldwide travels, from dealers, and at auctions.

Pillow cover, 20″ × 20″, quilted by Kelly Cline: known as "Society Silk embroidery," popular 1880–1910
Photo by Kelly Cline

On our father's side, the pioneer story remained a bit of a mystery, and family lore proved less than accurate. Research for this book revealed more information, but some puzzling details remain. Our great-grandfather Anselm T. Holcomb, who was born in Ohio, made the decision to move to Hancock County, Illinois, after marrying Cora Furrow. Our grandmother Esther was born there in 1890. Shortly after her birth, the family made the journey to Oregon (via the Oregon Trail), where Anselm worked as a miner and had three more children.[29] In the 1905 census, however, Esther Holcomb (age fifteen) has made her way back to Coffeyville, Kansas, where she resides in a boardinghouse with the Smythe family and is also listed with the Wilson family.[30] Esther went on to marry Claude Triplett, a flour miller. The parents of our grandfather Claude also made the pioneer journey, moving to Kansas in 1868, where Claude was born in McCamish Township in 1886. As children we visited our grandparents on the chicken farm. Our granddad still worked as a miller, but Grandma raised chickens and eggs for eating and selling to supplement their income.

Pieces of the Prairie

As work was completed for *The Pioneer Story through Quilts: Special Exhibition of the Poos Collection* at the Tokyo International Great Quilt Festival 2015, we realized we wanted to continue this work. Guilds began to book our pioneer program to see the quilts.

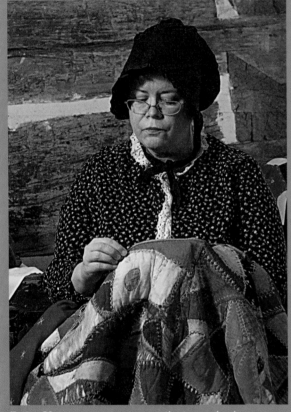

It was decided that we needed a storyteller to help people experience the pioneers' journey through the quilts, not just look at the quilts. Thus was born fictional pioneer woman Esther Heinzmann, the Quilt Treasurer.

Esther Heinzmann, restoring a quilt given to her by a woman from Topeka, Kansas
Photo by Matt Huddleston

Esther was named to honor our grandmother on our father's side, but she is not a biographical portrayal. The Germanic last name was chosen because, while we have a British heritage through the early pilgrim phase of our families, we have German ancestry on both sides of the family. The German presence was particularly strong during the pioneer period of our heritage, with part of our family emigrating from Germany at the end of the nineteenth century. Also, the influx of homesteaders with a German heritage was significant numerically, which had a large impact on the plains itself. Thus Esther is a creation based on historic fact, family experiences, and the amalgamation of the many pioneer journals.

The quilts pulled from the Poos Collection to create the story are all nineteenth-century quilts and period appropriate. Nevertheless these quilts are used to help depict the fictional tale, since in most cases we don't know where the quilts originated. If a featured quilt has a Great Plains provenance, that is noted. It is also important to remember that just as people were migrating from different areas back East and from the South, so were the quilts. Many of the quilts were brought with the travelers,[31] and those quilts that were created on the plains were made with the techniques the pioneers brought with them. It would be inaccurate to say there is a "genre" of quilts defined by the prairie, but there are quilts that help define the pioneer life story.

Please enjoy Esther Heinzmann's tale of the pioneer journey through quilts. She's quite a character.

ESTHER HEINZMANN TELLS TALES OF THE PRAIRIE THROUGH QUILTS

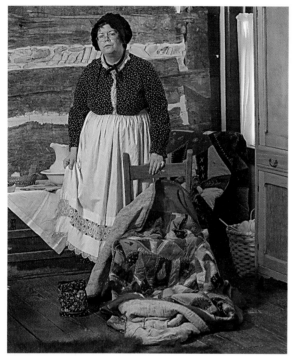

Esther Heinzmann, a widow, places the quilt on the chair instead of taking her husband's proper place.
Photo by Matt Huddleston

staying in the sod home. It was only recently that I had to sell our land and move into the big city. I'll have you know there are now eleven buildings in our town, including the one-room schoolhouse. I live in the local boardinghouse, which is where I got my nickname. They call me the Quilt Treasurer because, well, I love quilts. I appreciate the quilts for the skill of the maker, for the art of the craftsman or woman, and most of all, for the stories they can tell.

The one-room schoolhouse
Photo by Kevin Schuchmann

My name is Esther Heinzmann, and some people know me as the Quilt Treasurer. I homesteaded on the plains with my husband for many a year. Even after he passed away, I saw no reason to give up our place. You see, I love the prairie. I love the sound of the wind blowing over the plains, the smell of the rain as the storm approaches from afar, and the peaceful solitude of living miles away from another homestead, yet still close enough to visit and help your neighbor with only half-a-day's walk.

Sadly, at my age, farming got to be too much. You try going out to feed the livestock in the middle of a blizzard—that will right change your mind about

My quilts have come to me in a number of ways. Some of the quilts were given to me because the givers knew I would cherish the quilts. Sometimes the quilts were left by the side of the Santa Fe Trail by people who were trying to lighten the load of their covered wagon. Other times people, desperate because of the tough times on the plains, would give up their homestead and sell me their quilt treasures for funds to return back East. Even if a quilt was past its life expectancy (like I am), I treasured this piece of art. Occasionally I've bought a quilt from a traveling peddler, a sort of seller of quilts, but that quilt has to be very special. Let me just say, extra special! Enough said about me—let's talk about quilts!

Friendship Quilt
86″ × 88″ (c. 1856)

Once people or families decided to make the difficult journey to a new land, the realization struck that they would leave many loved ones behind. Families and friends wanted to provide a memento that would offer comfort during the arduous journey. Because we pioneers could take so little, the memento also needed to be functional. A quilt providing warmth as well as memories of loved ones and friends was the perfect solution. This quilt was created by a New York Huguenot family, the Dubois and Spoonmaker family. The Spoonmaker's younger brother made the difficult journey to homestead and raise livestock in Mira, Nebraska.

This is an album quilt with 36 blocks, each bearing a signature, and a wonderful floral border. Only 1 block, the Basket block, is pieced; the rest are laid on, or what the French call *appliquéd*.

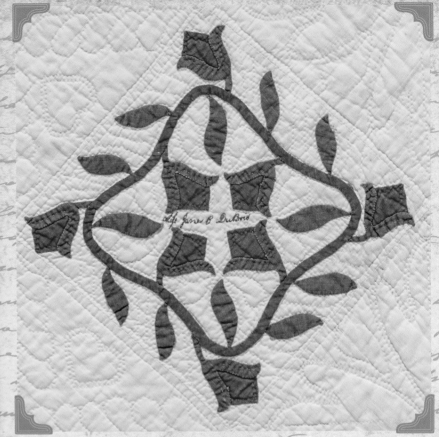

Eight Rosebud Square block

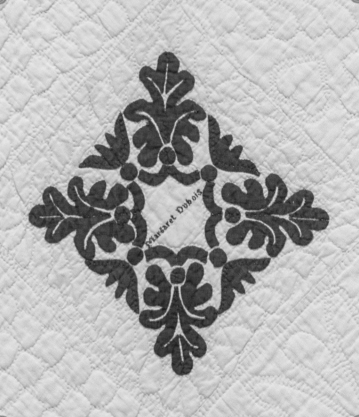

Fancywork block, one of the five blocks that is repeated

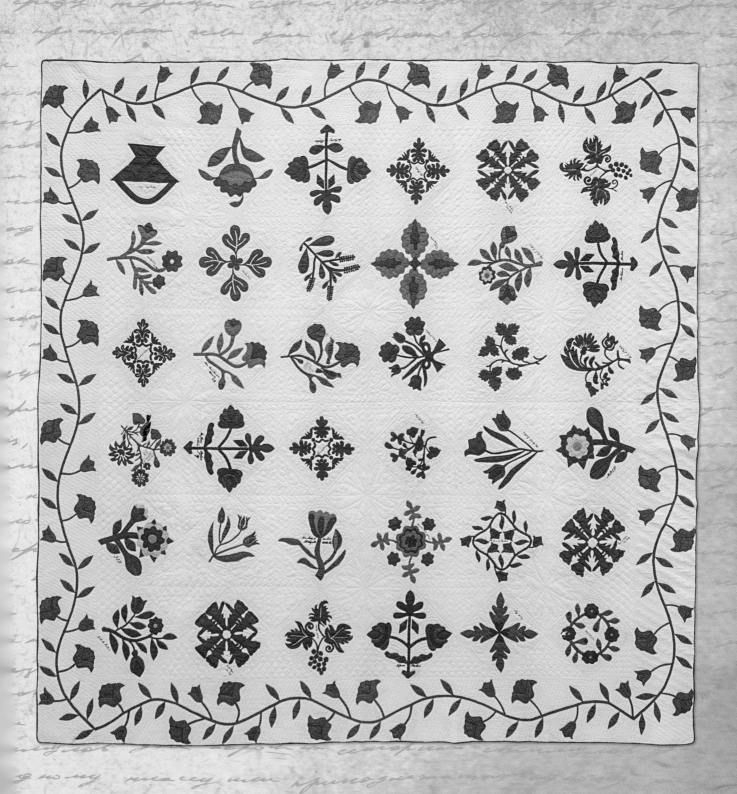

Wagon Wheel and Oak Leaf
74" × 82" (c. 1860)

Because the wagon was usually full of supplies for a family's new life, many of the pioneers walked beside their wagon. This quilt pattern was inspired by a woman walking alongside the wheel of the wagon that would carry their life to the new land. The oak leaf was added as a reminder for them to be like the oak tree: strong as well as courageous through the long and difficult journey.

The use of only two colors creates a graphic effect, which is enhanced by the twisted border. The more commonly known name of the block is Oak Leaf and Reel, originally inspired by the spinning jenny.

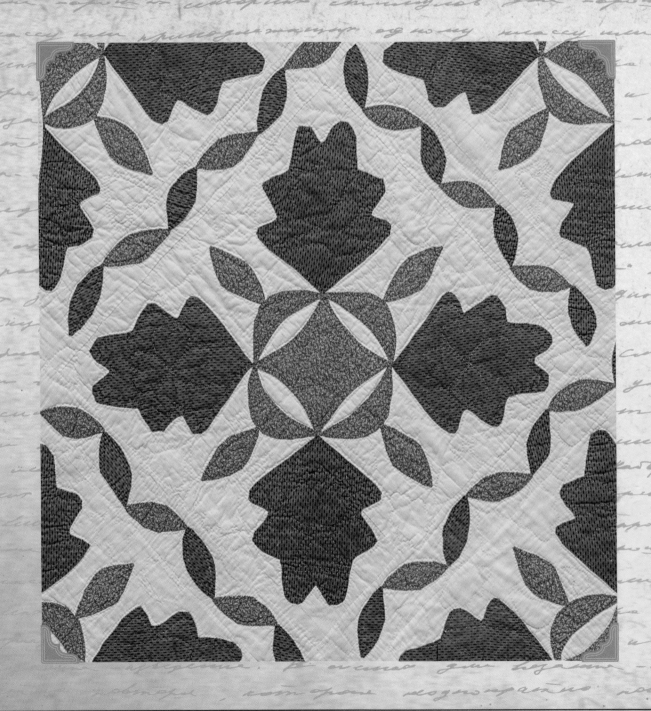

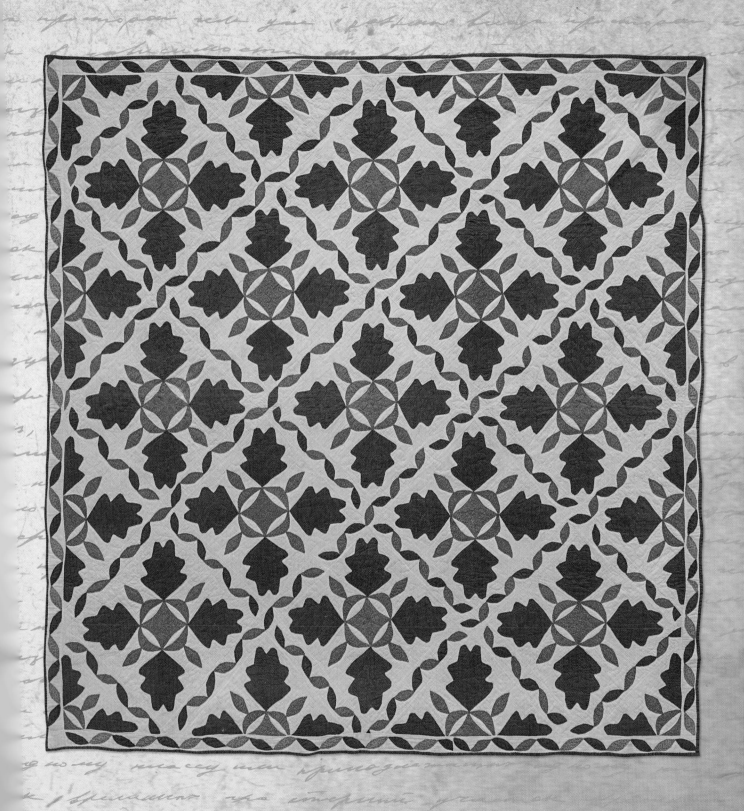

Delectable Mountains
103" × 103" (c. 1850)

Each pioneer was limited in what they could take on the journey. Many sold all of their belongings and traveled simply on their horse or mule, or even tougher, walked with the wagon train. If they did take furniture for the new sod home, it was taken apart to occupy the least amount of space, even sliding under the wagon seat. Space was allocated for needed supplies and food to build a new life.

Even with the limited number of items that could be taken on the journey, two books traveled with the majority of those going west: the Holy Bible and *Pilgrim's Progress*. This quilt pattern is inspired by the eighth section of the journey in *Pilgrim's Progress*. A pilgrim longs for the delectable mountains because those "mountains belong to the Lord;" in the delectable mountains there is protection for those who make the journey.

This quilt has a center medallion format, but added borders of quilting interspersed with the Delectable Mountain blocks add to the complexities. Notice the star, created using the Delectable Mountain block, and the amazing quilting.

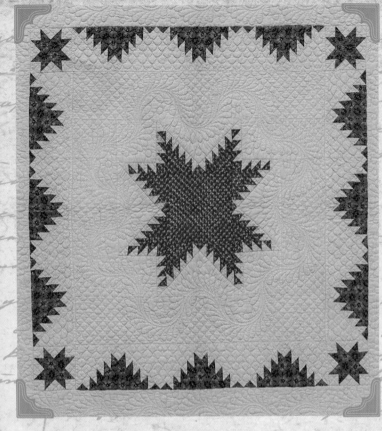

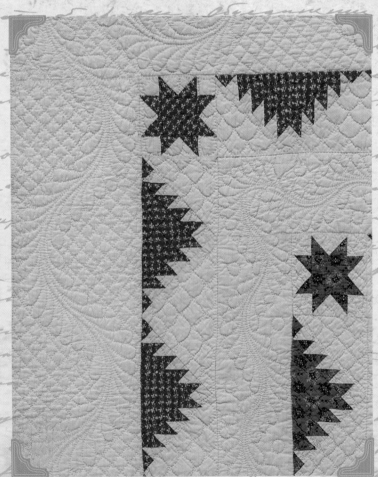

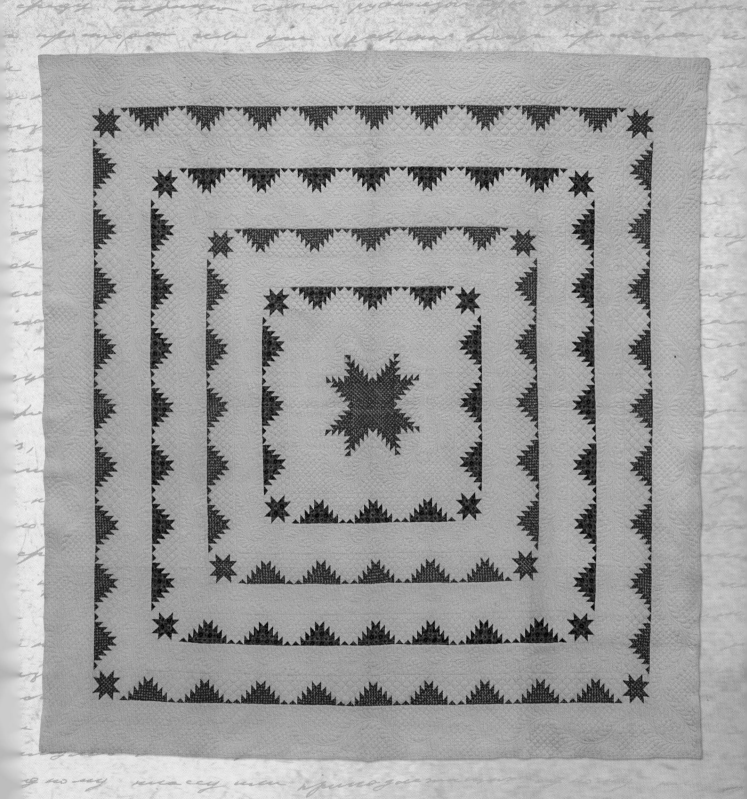

Jacob's Ladder / Trail of the Covered Wagon
68″ × 78″ (c. 1880)

The Holy Bible was the most popular book for us pioneers, and our Christian faith was a major part of our lives. Services were held as a regular part of the journey, as well as funerals after deaths. Some pioneers packed boards to build coffins and shrouds or quilts to cover loved ones who did not complete the journey. Luckily, I never needed mine.

Jacob's Ladder was a particularly appropriate pattern for us pioneers, since it told of the Lord giving "the land on which you lie." The ladder comes in Jacob's dream as the angels ascend and descend from heaven. Other biblically themed quilts popular on the prairie include Job's Tears and Job's Troubles, which would eventually become known as Kansas Troubles because of the difficult life on the plains. The pattern of this quilt later became known as the Trail of the Covered Wagon,[32] inspired by the deep ruts left by wagons on the trek west. I know those ruts will exist for centuries to come!

The Jacob's Ladder pattern varies slightly from the better-known Irish Chain. Notice the block with grid quilting.

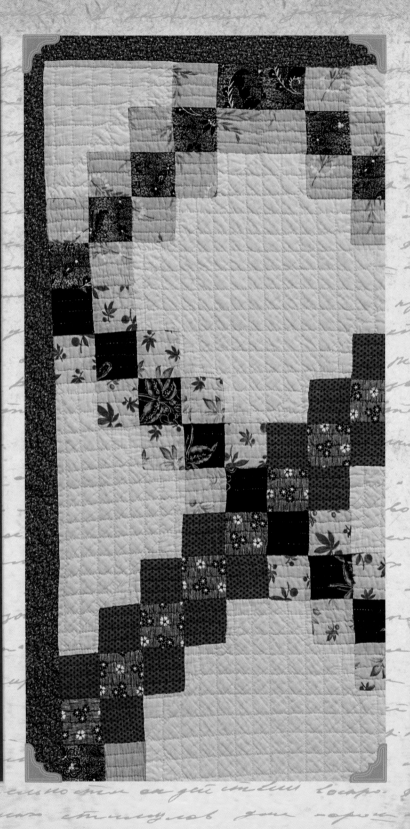

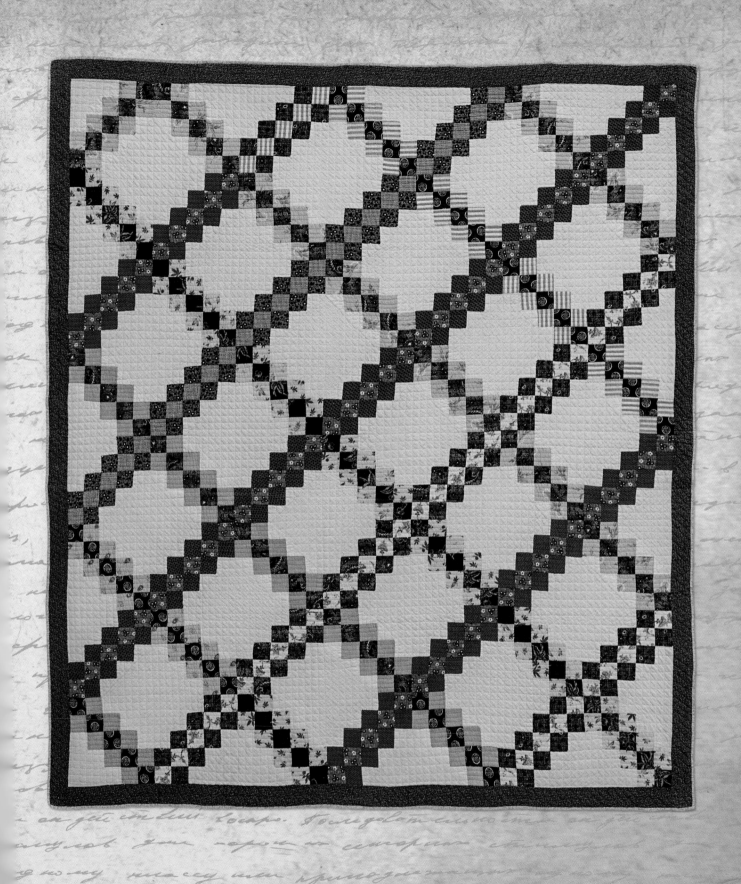

Pomegranate with Star and Pot of Flowers Border
82″ × 82″ (c. 1860)

The pomegranate has had special religious meaning for longer than I can imagine. It is a symbol of Jesus's suffering and resurrection that is used in tapestries, quilts, and even floors. One of my neighbors from Dorset, England, told me about a fourth-century Roman mosaic floor that shows the pomegranate surrounding Christ. I hear tell this is one of the earliest depictions of Christ, and because of that, they moved the old floor to the British Museum.

This special quilt came from a family in Ohio. Notice the beautiful Pot of Flowers border and the buttonhole stitching.

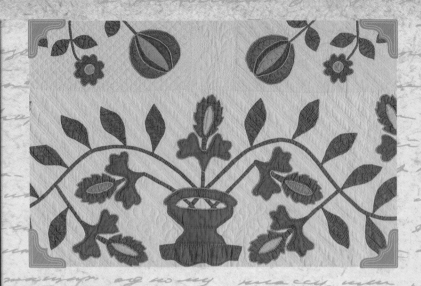

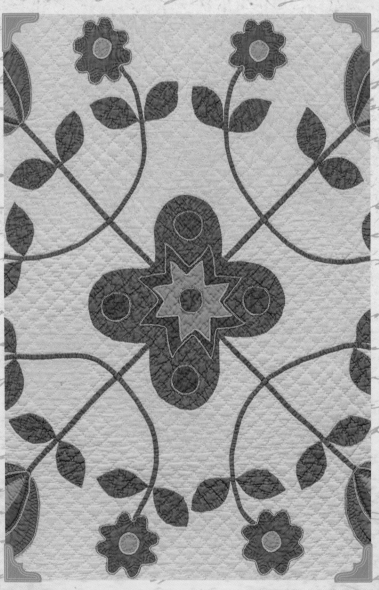

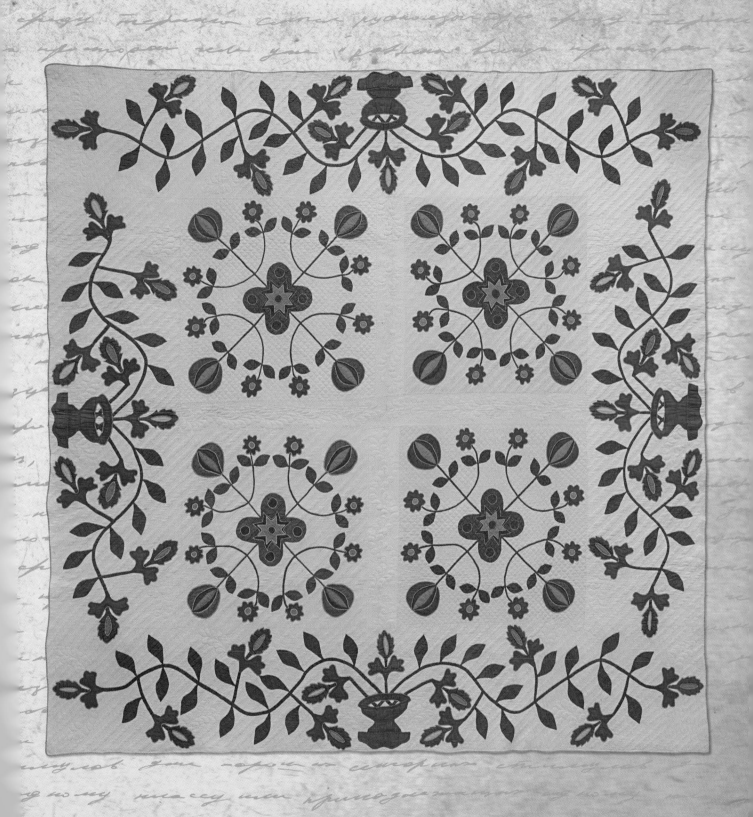

Wild Prairie Rose
76″ × 85″ (c. 1860)

The Rose of Sharon quilt pattern name was another biblical reference from the Song of Solomon (or Song of Songs), a book in the Bible, and was frequently used in songs, poetry, and quilts. As we pioneers came to claim our new life on the plains, we began to change the name of this quilt block to reflect our life. The pattern later became known as the Wild Prairie Rose.

Note the nine laid-in roses, surrounded by a vine border with roses.

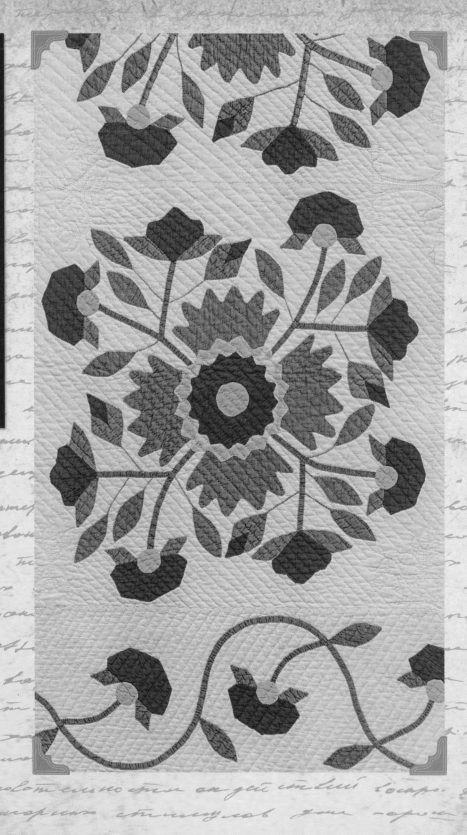

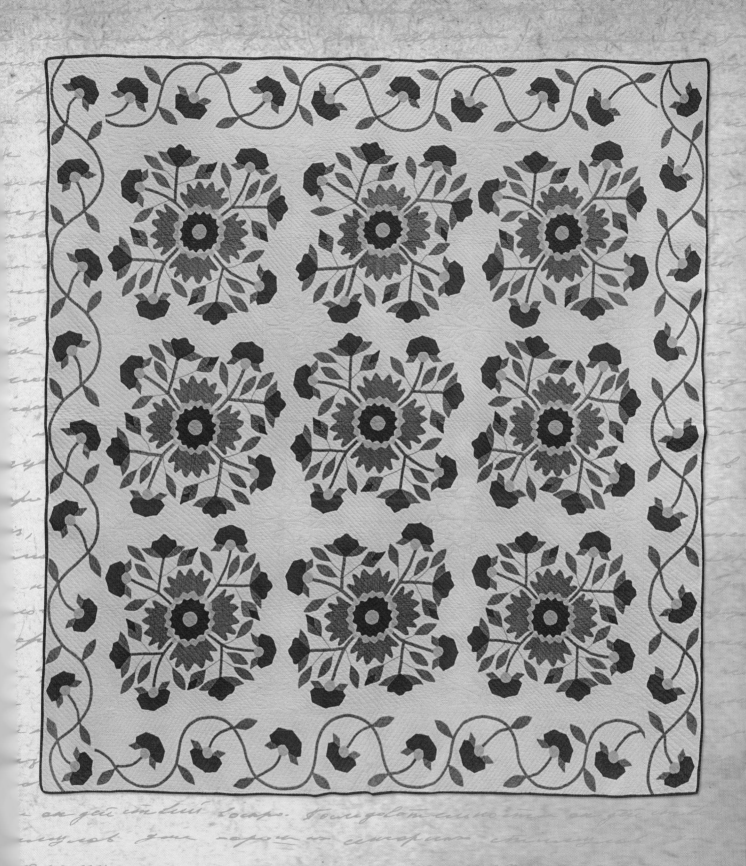

Watermelon Quilt
86″ × 86″ (c. 1860)

You'll notice the center blocks are similar to the Rose of Sharon block—except with tulips this time—but the quilt's distinctive border is the eye-catcher. A lot of the plains patterns relate to food, and as you can probably tell by looking at me, food is a favorite topic of mine. There is nothing like a wild watermelon in the heat of August to quench your thirst and give your day a boost. The Native Americans even dry watermelon slices to make soup. I can't rightly waste a good melon by drying it; I'd rather eat it and savor it when fresh. I suspect this quilt artist treasured the fruit, too, or else the melon wouldn't have made it to a special place on the border. On the plains, we hold festivals for watermelons in Kansas, Oklahoma, Iowa, and Texas.

> Notice the Tulips with Buds block, grid quilting, and watermelon border with a scalloped edge.

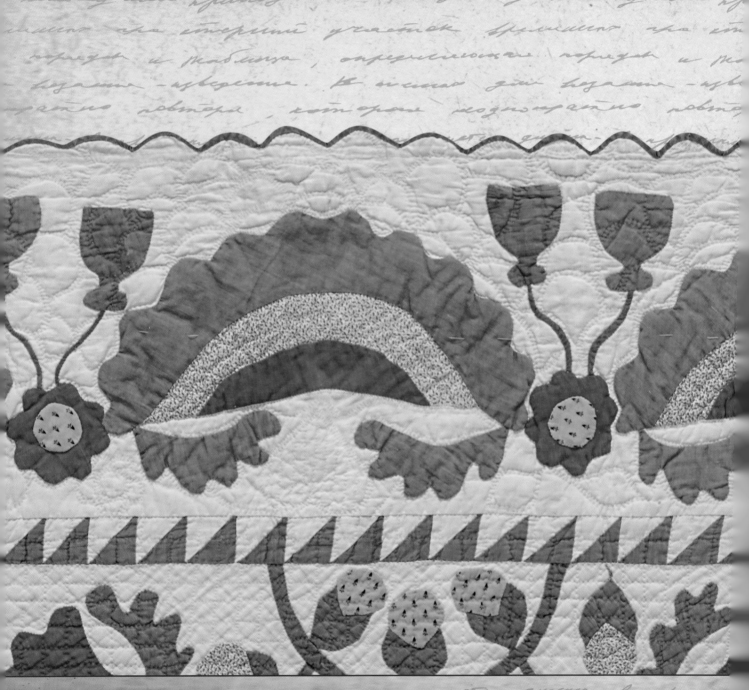

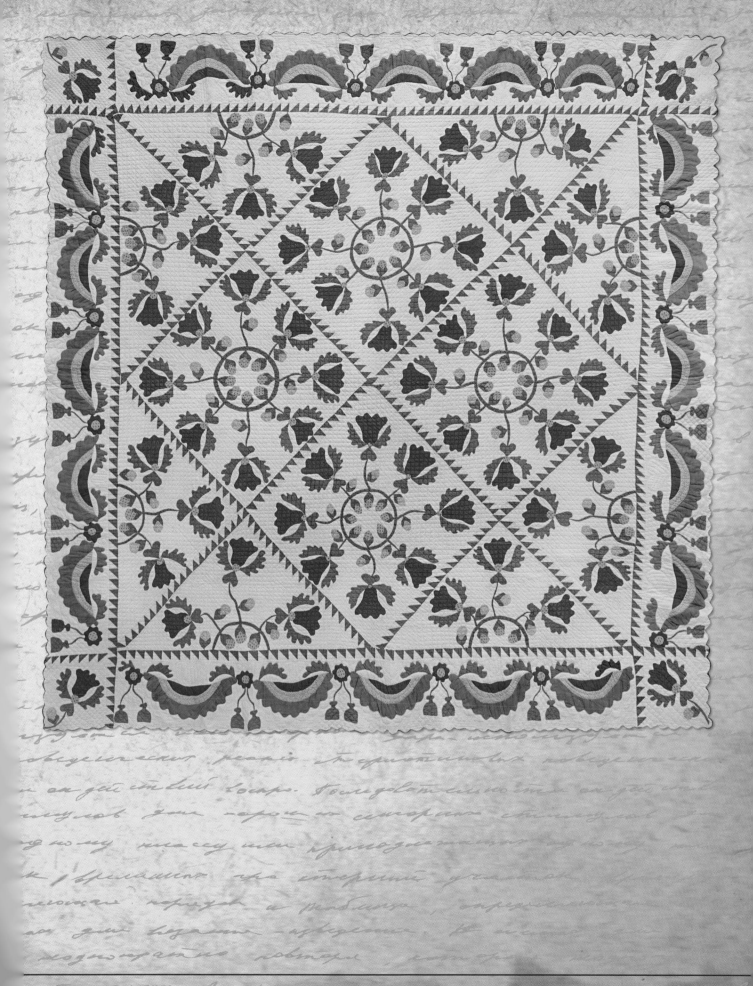

Bear's Paw
76″ × 78″ (c. 1870)

Bears were both a hazard and a blessing on the journey. A bear could easily attack and kill, but if a pioneer could kill a bear, it could provide a lot of meat for the journey and warm fur for blankets. I always fancied a bear-fur coat myself, even though I never got it. Although bears are not commonly found on the prairie, areas surrounding the plains provided plenty of encounters with bears. Trappers would row down the river and stop at the trading post in Kansas City, Kansas, trading pelts for supplies and telling tales of bravery.

This is a well-loved quilt, pieced with a variety of scraps and Bear's Paw blocks with setting strips and cornerstones.

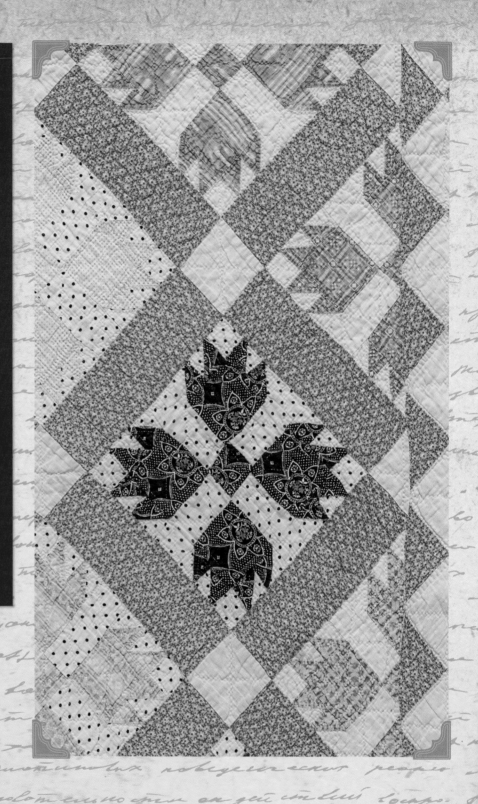

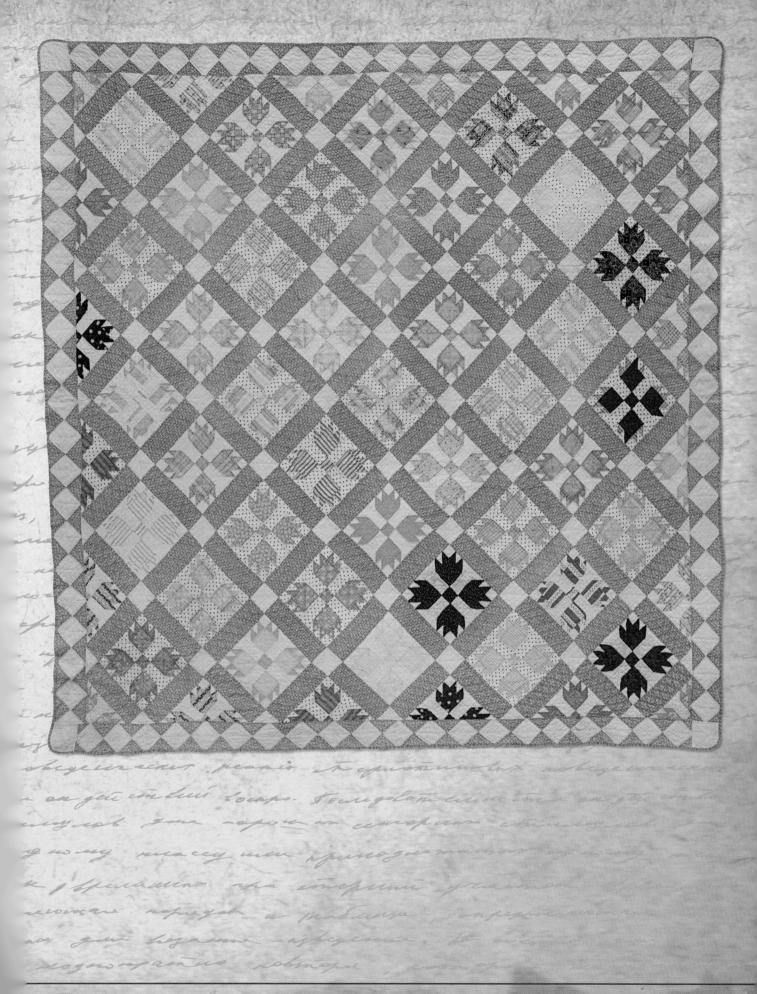

Wild Goose Chase
66˝ × 80˝ (c. 1875)

Geese were a treasure on the prairie, providing food and eggs, but they were also the seasonal forecast system. Birds flying north meant that winter was at an end and it was time to continue the journey, or if you'd found a homestead, it was time to plant crops. Birds flying south were a warning that winter was coming and it was time to prepare for the harsh snows and below-freezing temperatures. Many quilts simply show the birds in a direct line, easily reminding the pioneers of the seasons and the joys and sorrows associated with each. This quilt artist got a little creative and had the birds at a "crossroads," flying in all directions.

"Madder" red and green was a popular color scheme; it was colorfast, readily available, and contained the complete color wheel. This is the Wild Goose Chase block with dark thread, a technique some attribute to a Southern quilter.[33]

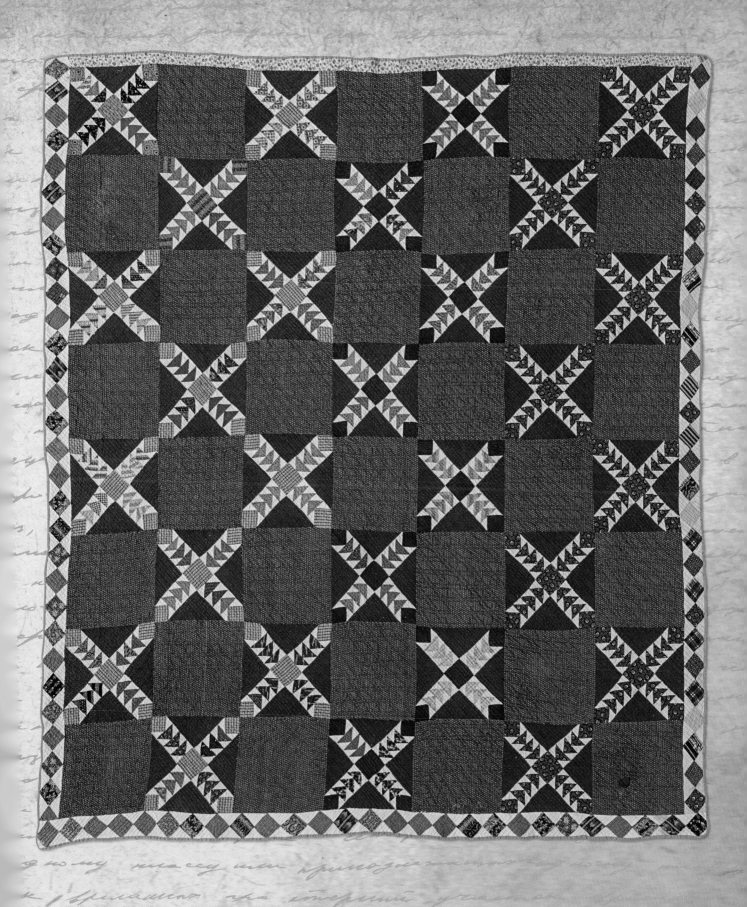

Turkey Tracks
70" × 86" (c. 1850)

The turkeys of the plains provided meat, eggs, and humor—have you ever seen a turkey walk? The turkey's distinctive tracks could also provide a clue where to find water, since turkeys get a drink of water each evening before retiring to their roost. Simply follow a turkey at dusk, and eureka, you've found water!

Ben Franklin wanted the turkey to be chosen as the national bird, but it lost out to the majestic eagle. I'm sure turkeys will still be celebrated in America in future festivals by both Native Americans and descendants of Europeans.

Twenty Turkey Tracks are surrounded by a stair-step border usually associated with the East Coast. Remember, however, that the story of the plains is a story of migration, with people bringing quilts and techniques from their previous home. Notice the amazing quilting.

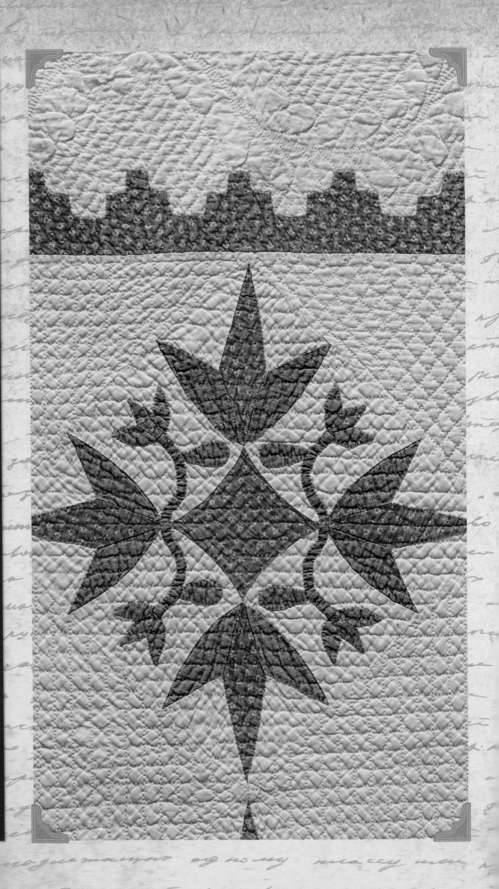

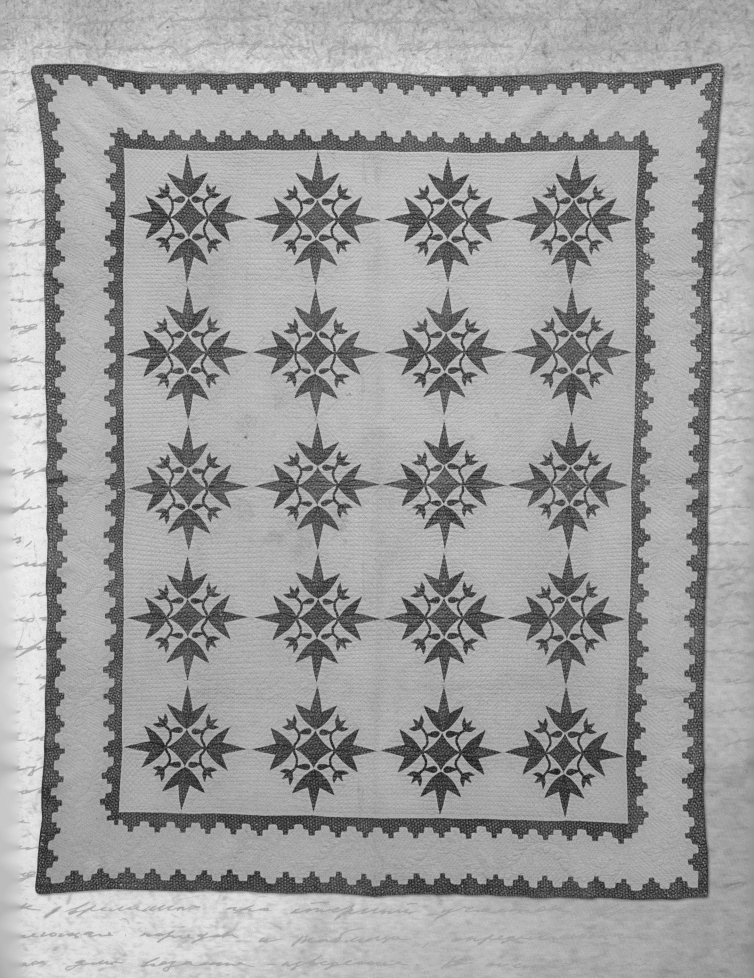

Pine Tree Quilt

66″ × 80″ (c. 1860)

The pine tree also has a special place in our hearts. It is one of the few trees that grow on the plains, providing protection against the prairie winds and winter blizzards. Most of us started out in sod houses, but when we graduated to a wooden house, it was usually made out of pine. Same for the furniture—when made of wood, it was constructed from pine or evergreen trees. As German immigrants (such as those in my family) reached the plains, the pine tree was a pattern that was used frequently at Christmas time. We called it *O Tannenbaum*! When poorer families couldn't afford a real Christmas tree, we hung up a quilt on the wall in place of the tree.

This quilt includes twelve Pine Tree blocks with a variation of the block used in the corners.

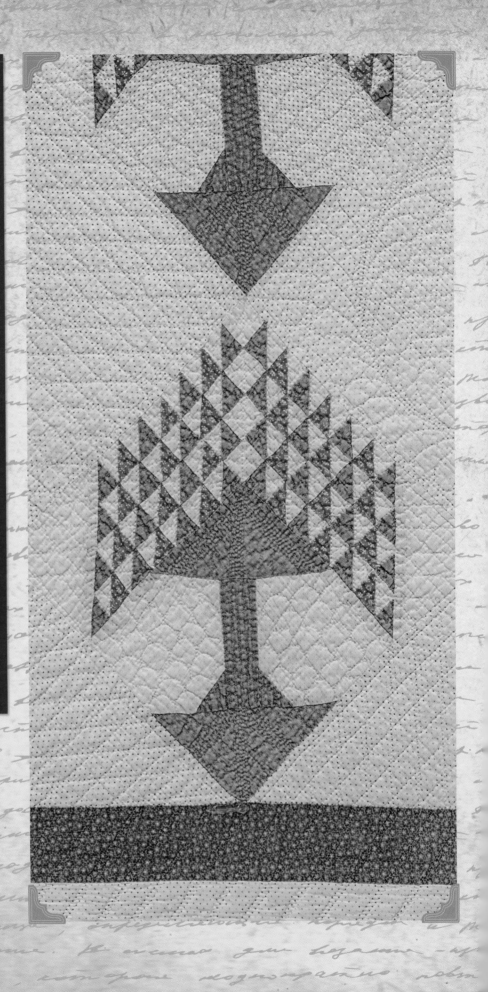

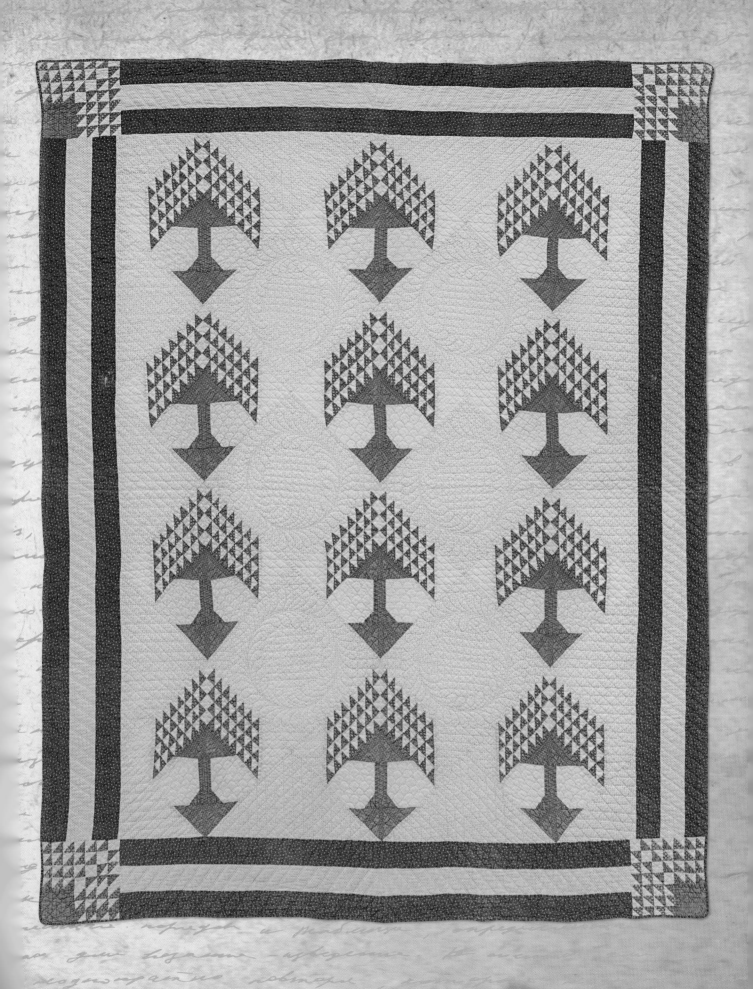

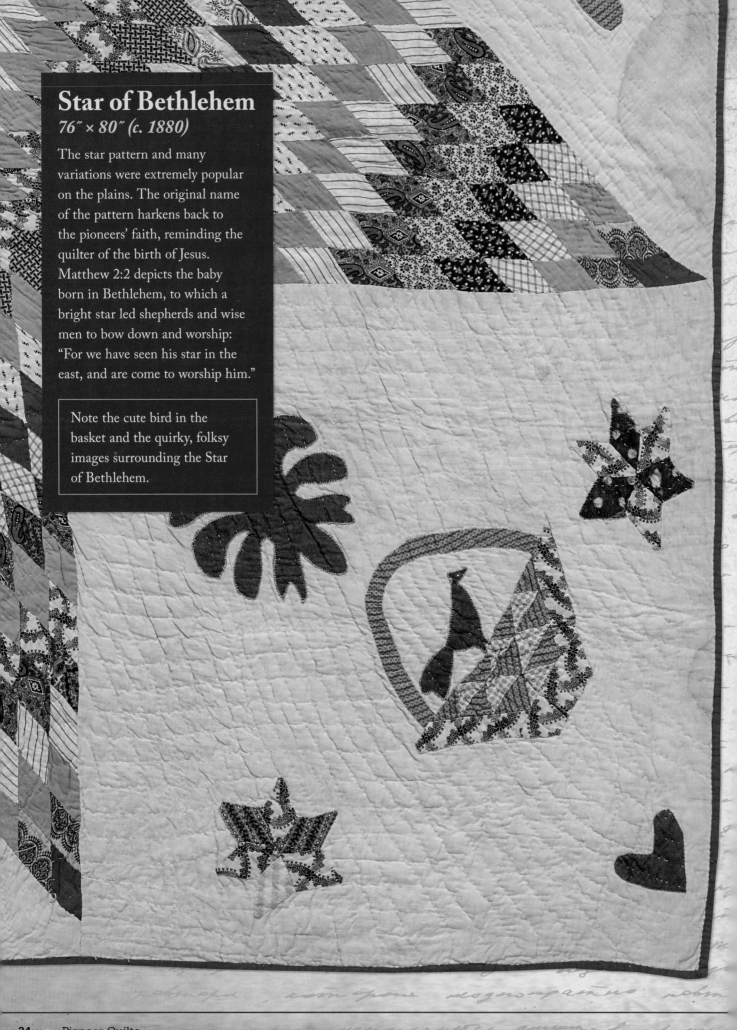

Star of Bethlehem
76″ × 80″ (c. 1880)

The star pattern and many variations were extremely popular on the plains. The original name of the pattern harkens back to the pioneers' faith, reminding the quilter of the birth of Jesus. Matthew 2:2 depicts the baby born in Bethlehem, to which a bright star led shepherds and wise men to bow down and worship: "For we have seen his star in the east, and are come to worship him."

Note the cute bird in the basket and the quirky, folksy images surrounding the Star of Bethlehem.

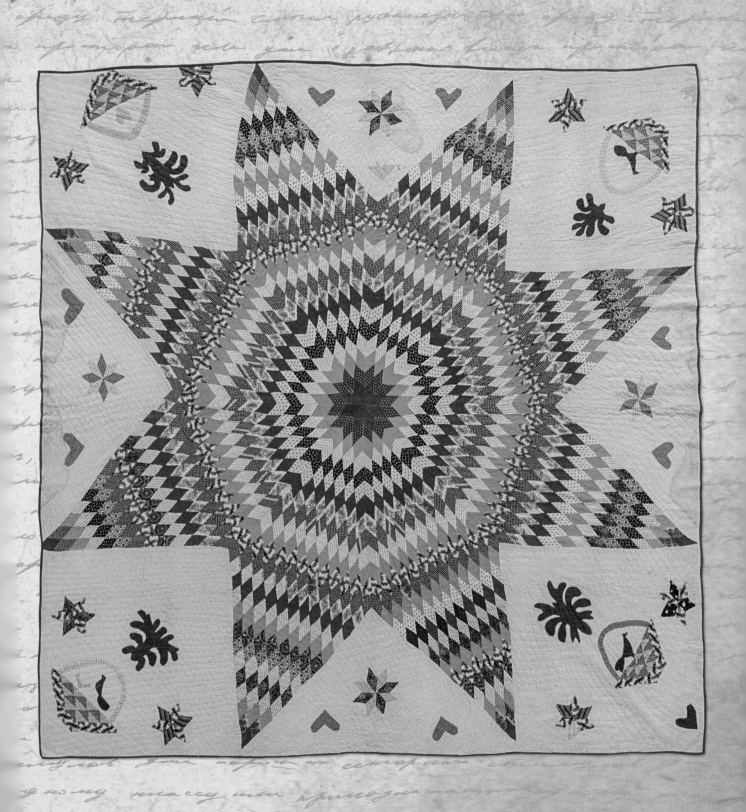

Diamonds between the Stars
60″ × 74″ (c. 1870)

As the popularity of the star patterns grew, a variety of patterns and names developed, including Lone Star, Sioux Star, and Morning Star, which were derived from the American Indians. Star of the West (also called Western Henry or Clay's Choice) commemorated the Missouri Compromise. Then there are Lemoyne Star, Lemon Star, Variable Star… the list goes on.

It appears that the tan stars were a fugitive green, a dye that "ran away." There also appears to be some fugitive color in the diamonds. Notice the amazing quilting and the *A B* embroidered in one corner on the back.

Four Stars with Floral Border
82″ × 86″ (c. 1840)

In Kansas, star patterns played an even larger role. The state motto is *Ad astra per aspera*, which is Latin for "to the stars through difficulties." The never-ending list of star patterns that we Kansas pioneers used include Kansas Star, Waverly Star, Leavenworth Star, Lawrence Star, and Tonganoxie Star. I'm thinking you get the idea—add the name of your town with "Star," and good heavens, you've got a new quilt block name!

Filled with stars, the floral border really catches the eye and completes the quilt. Feathered wreaths are quilted in the blocks between the star blocks, and grid quilting is used in the star blocks.

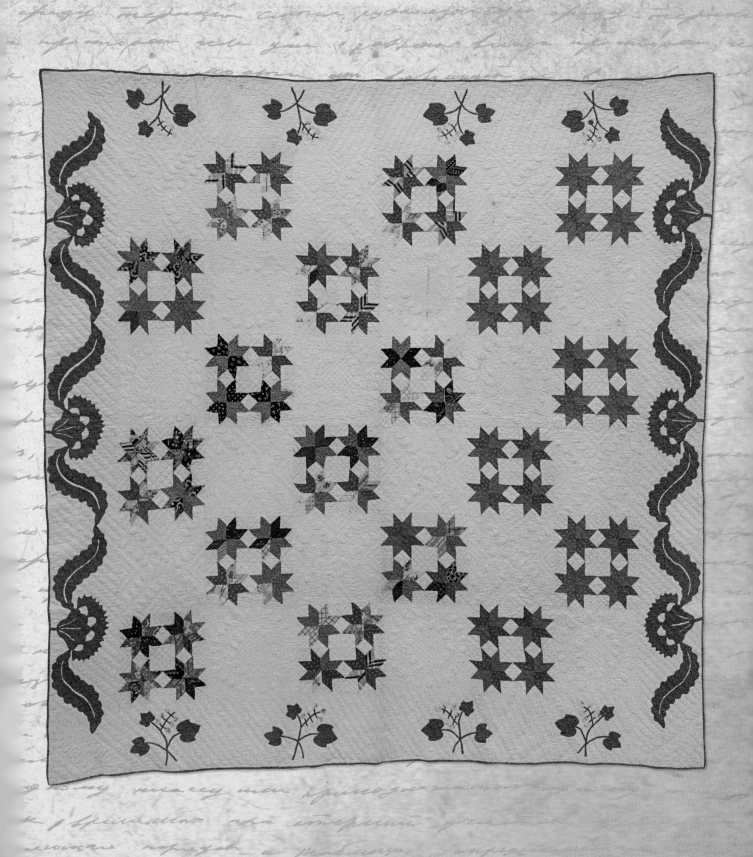

Sunburst and Lily
84″ × 85″ (c. 1860)

This here pattern developed as a variation on the Mariner's Compass, transforming it into the Sunburst. In the middle of the plains, the ocean seemed irrelevant to we pioneer women. But the blazing sun "was a reality we could understand," wrote one woman in her diary about riding over to El Dorado, Kansas, to draw a copy of the Sunburst pattern. The lily had special meaning for the plains women as well. The Indians considered the lily a sacred plant because in times of scarcity, it had an edible bulb that could be made into a soup. I have to tell you, lily bulb soup is an acquired taste—one I haven't acquired.

There are 21 Sunburst blocks alternating with 21 Lily blocks, surrounded by a swag-and-tassel border on 3 sides.

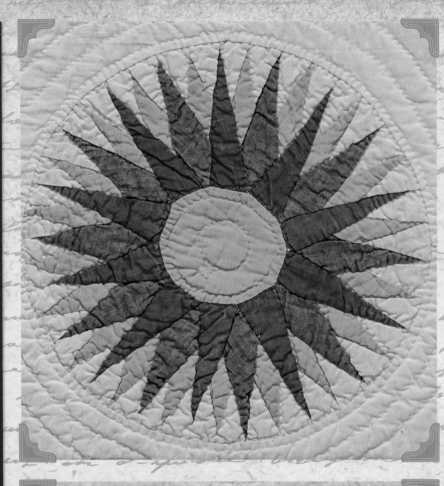

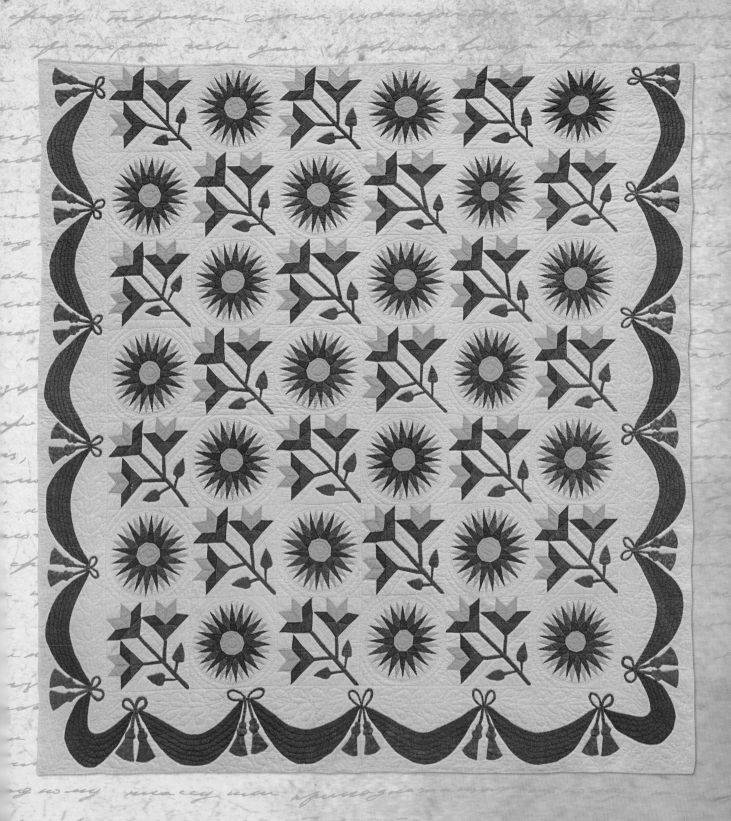

President's Wreath
78″ × 78″ (c. 1860)

Although some say this block commemorates Grover Cleveland, I know of a President's Wreath quilt finished in 1850 in Pennsylvania, long before Cleveland ever served. The President's Wreath became a popular symbol for bride's quilts or dowries, especially with the trumpet version. With all the hearts in the quilting, I like to think of this as a bridal quilt.

This quilt features President's Wreath blocks with buds instead of the trumpets, as usually seen on President's Wreath quilts. A rose vine border surrounds the blocks.

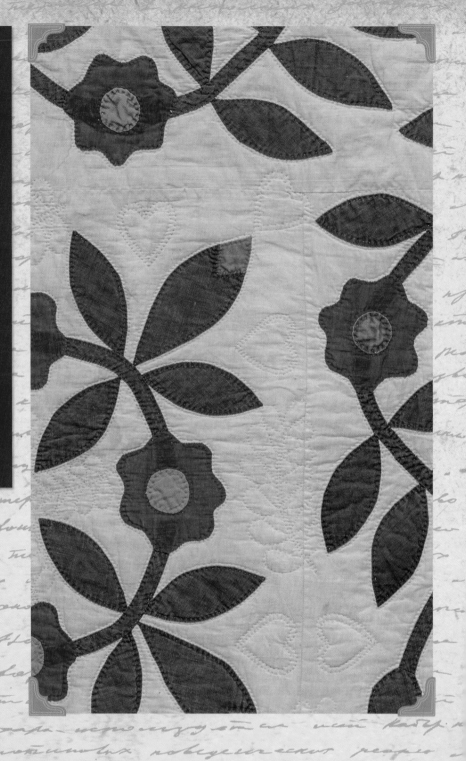

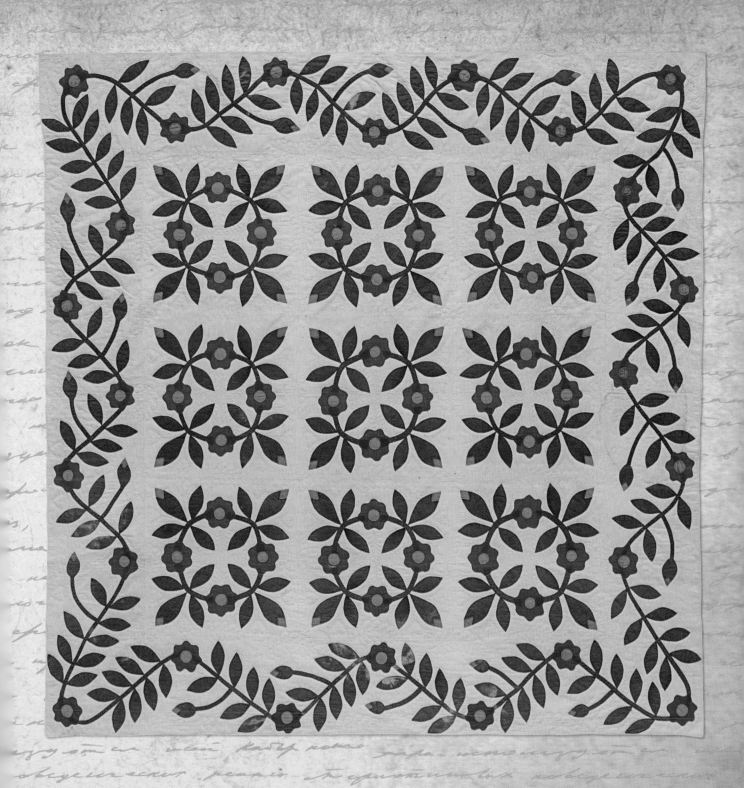

Basket
60˝ × 80˝ (c. 1870)

On the plains, neighbors got together to help each other at a barn raising or perhaps just to celebrate, which frequently meant eating together. The Basket pattern and the similar Cake Stand were inspired by the ladies bringing their food in baskets or on cake stands to share with others. The quilt pattern was a reminder of a shared time of fun. I always like to call attention to the back of this quilt. It could be that it was a way to make do with smaller pieces of fabric for the back. I'll lay you odds someone in the future is going do this, thinking they made something up all modern and up-to-date.

A simple pieced basket with laid-on handles. See how the piecing creates bold stripes.

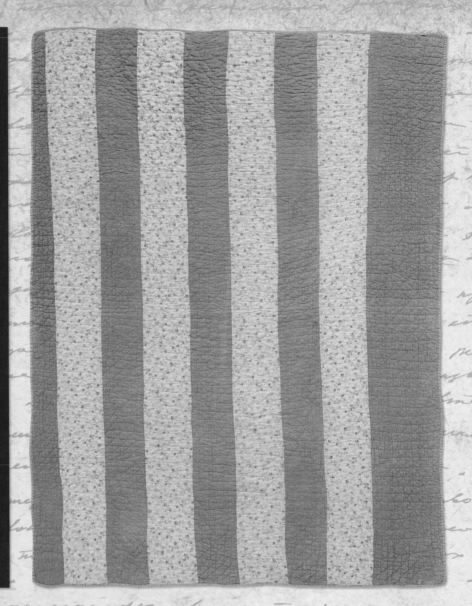

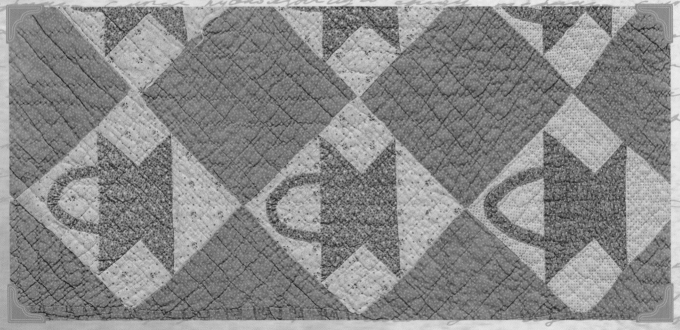

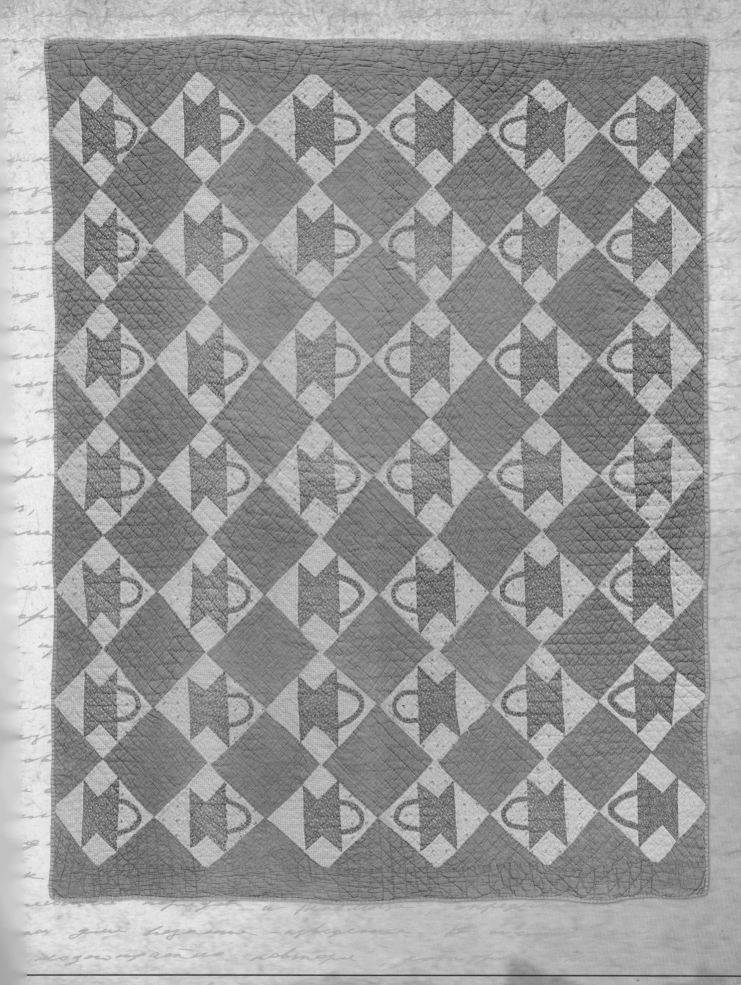

Cake Stand
56″ × 76″ (c. 1890)

The Cake Stand was a reminder of the cake-walk dance, where the winning couple won a big cake. The dances started earlier in the South, but when the cakewalk dance was shown at the Centennial Exposition in Philadelphia in 1876, it spread like wildfire across the country. It has been used at many a church fundraiser. In fact, I bet you've participated in one yourself!

Notice the vibrant polka dots that appear in the piecing and in the border frame of the quilt.

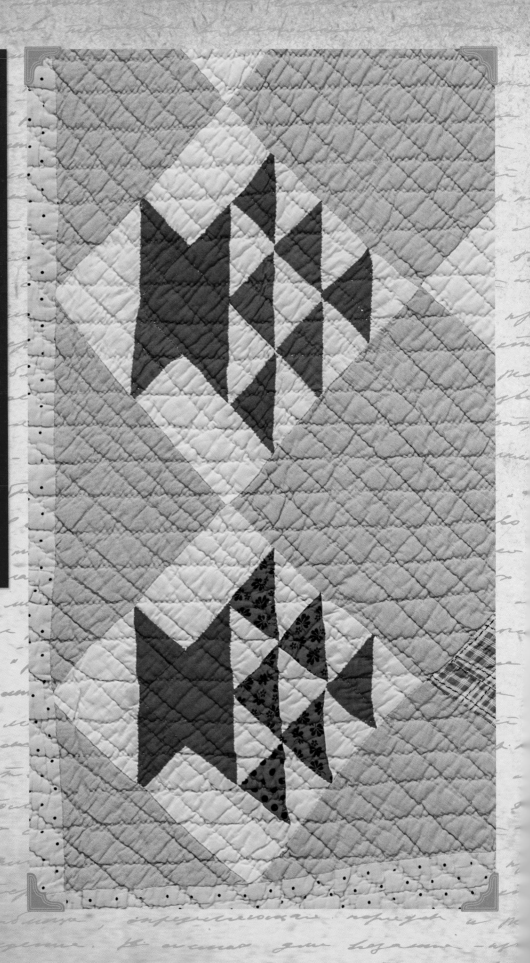

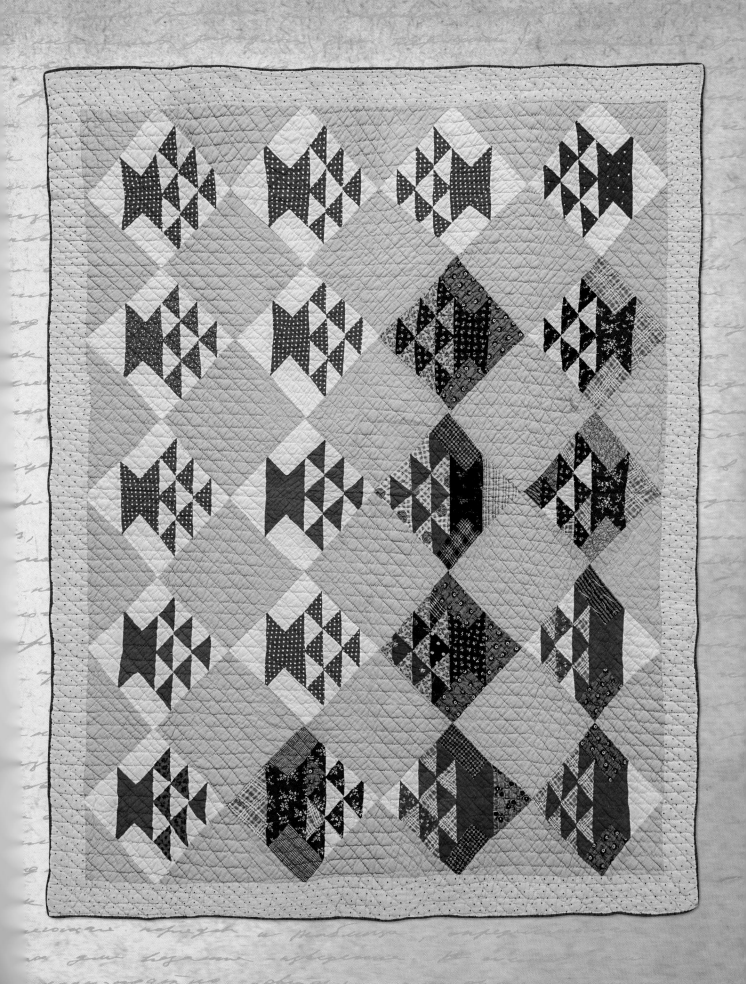

Chisholm Trail Quilt

78″ × 86″ (c. 1875)

This quilt pattern name was given to the newspapers by Miss Marjorie Prince of Lucas, Kansas, who called it the Chisholm Trail. I'm not rightly sure who originally named it. Most would recognize this pattern as an Ohio Star with a vine border.

The trail was used by ranchers during the nineteenth century to drive the cattle from Texas to the Kansas railroads. As you are sleeping on the ground during the cattle drive, all you see are the stars and scruffy vines beside you. The final destination of the trail for most of the cattle was either the northern trading post in Kansas City, Kansas, or the railhead of the Kansas Pacific Railway in Abilene, Kansas.

Note the vine border.

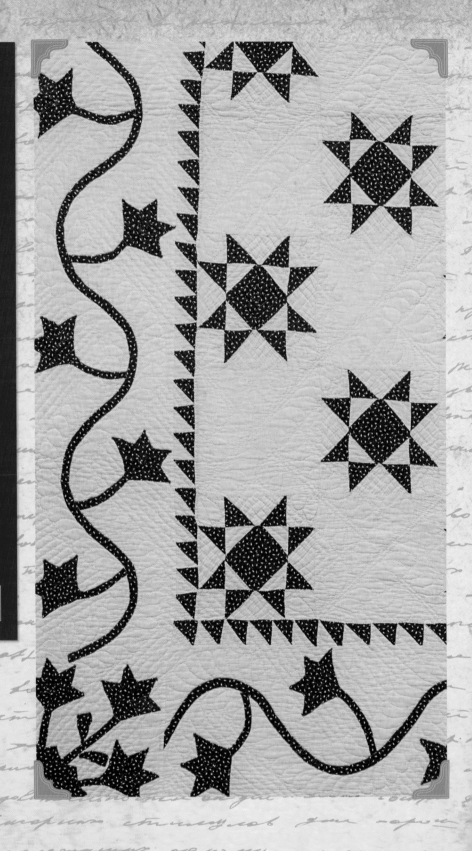

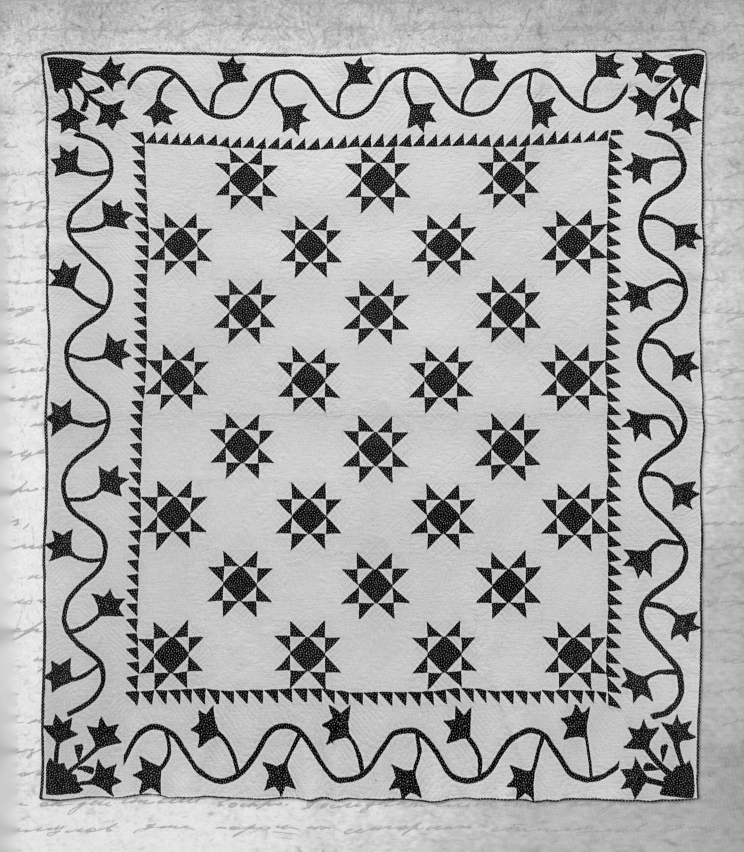

Nine-Patch Quilt— Reversible
78″ × 80″ (c. 1870)

The Nine-Patch is one of the oldest patchwork designs, one from which many different pattern blocks have been created. It was a quilt pattern that some children from the plains, named Laura and Mary Ingalls, both stitched. I've seen Laura's quilts, and she'll never be known as a quilter, but she sure can write. I wouldn't be surprised if she made something of her daily diary one of these days.

The quilt artist may have been clever to make this quilt fully reversible, saving time and energy by only making one quilt that she nevertheless could change with the seasons. Or perhaps she simply needed a thicker quilt.

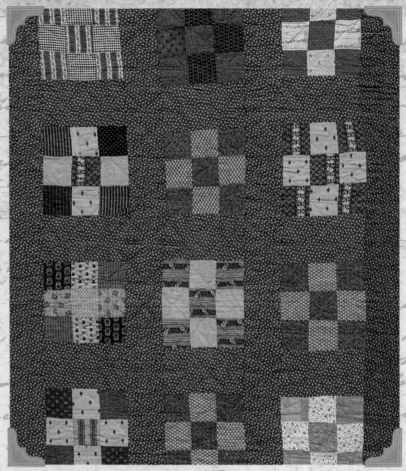

A close-up of the blocks

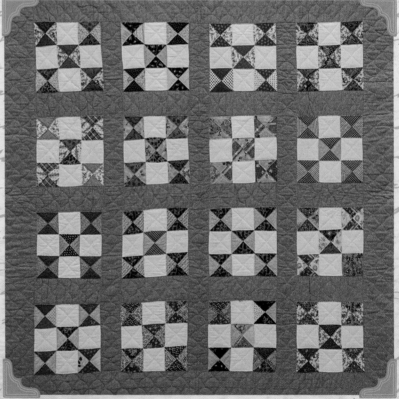

Blocks on the other side of the quilt

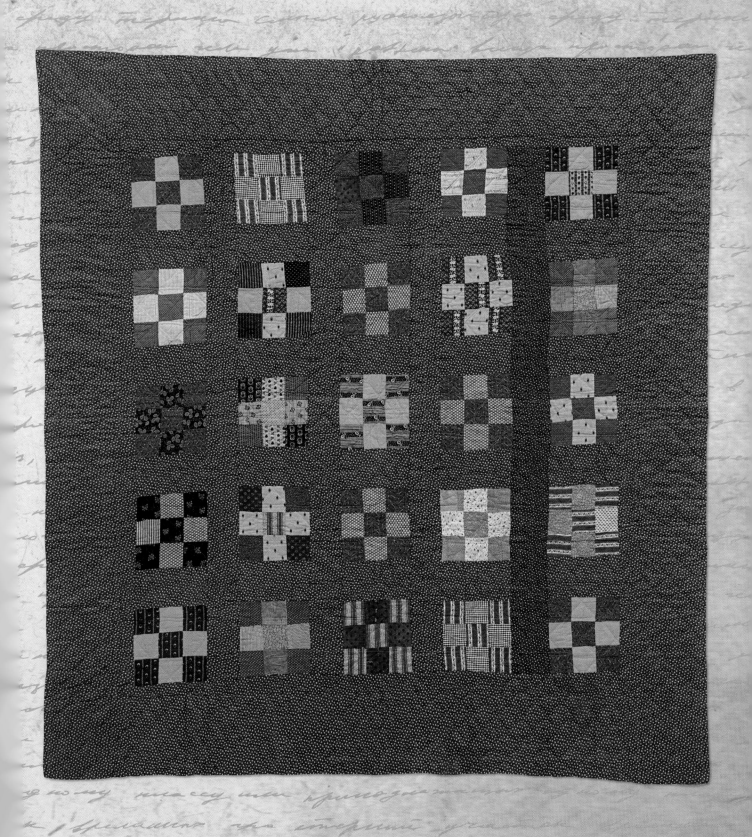

Red-and-White Nine-Patch
76″ × 80″ (c. 1870)

This quilter obviously had a lot on her hands with all the work to be done on the homestead. Piecing a nine-patch out of this many pieces would have required a lot of time. Instead, she found a unique way to "cheat" on the Nine-Patch block by using strips. I probably shouldn't call her a cheater, unless I'm willing to make all those nine-patches individually myself. Lord have mercy, I don't see *that* happening! Blocks with a white- or light-colored plain X in the center of the block were often used for album quilt blocks (friendship quilt blocks), since the X nicely framed the name and sentiment.

Nine-patch with crosses: ten white crosses and ten red crosses

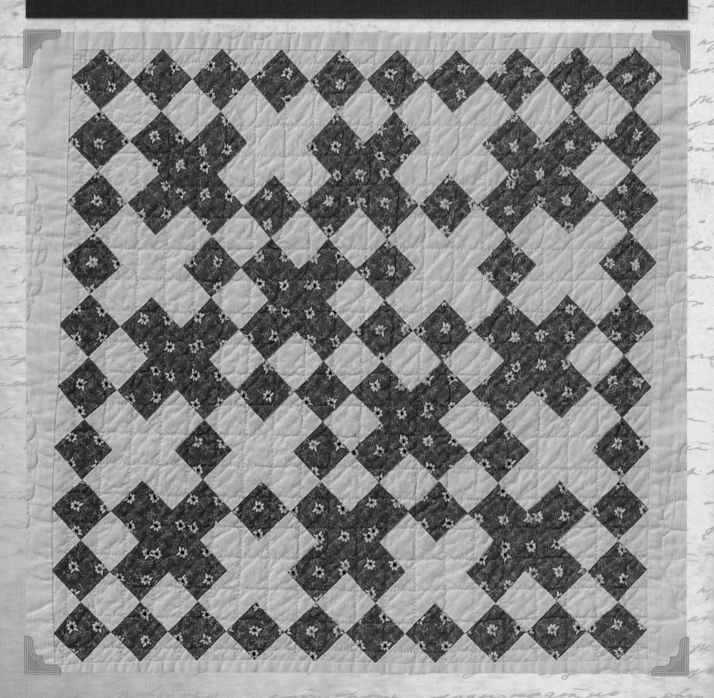

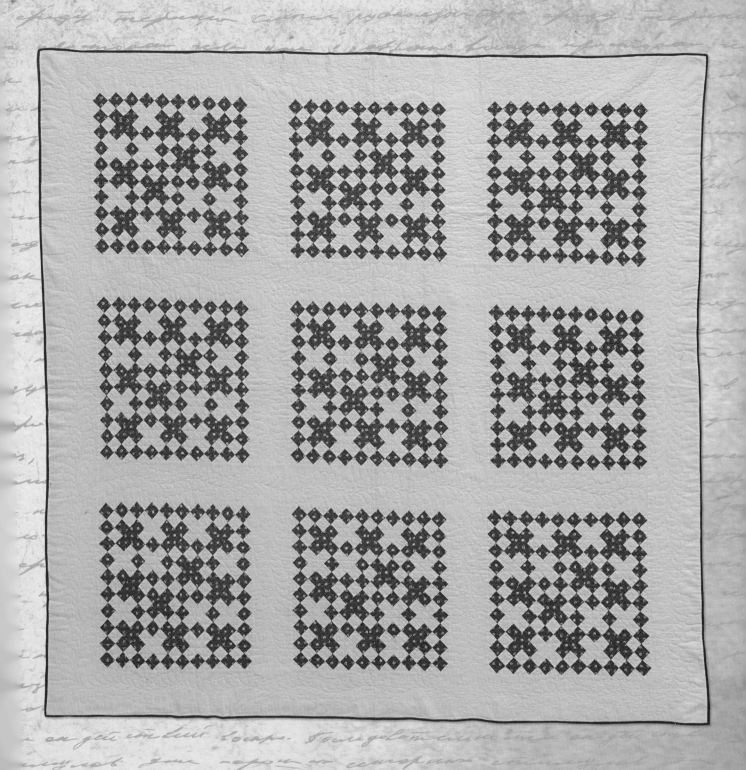

Sunflower and Nine-Patch
81″ × 88″ (c. 1850)

This quilt was brought to my attention at a quilt gathering. Two sisters owned the quilt, and they were willing to sell it to the Quilt Treasurer. Besides the amazing piecework, with even smaller nine-patches than I'd be willing to tackle, there were beautiful sunflowers. Very appropriate, considering that Catherine Snyder, the quiltmaker, came from Minneola, Kansas. She must have spent hours making her masterpiece. If I ever got the chance to meet up with her, I'd ask her two questions: Are those exquisite shapes in the border wheat waving in the prairie winds? Did you leave the fringe off the top part of the center so it didn't tickle you at the neck?

Note the delicate size of these patches and how the nine-patches form an Irish Chain.

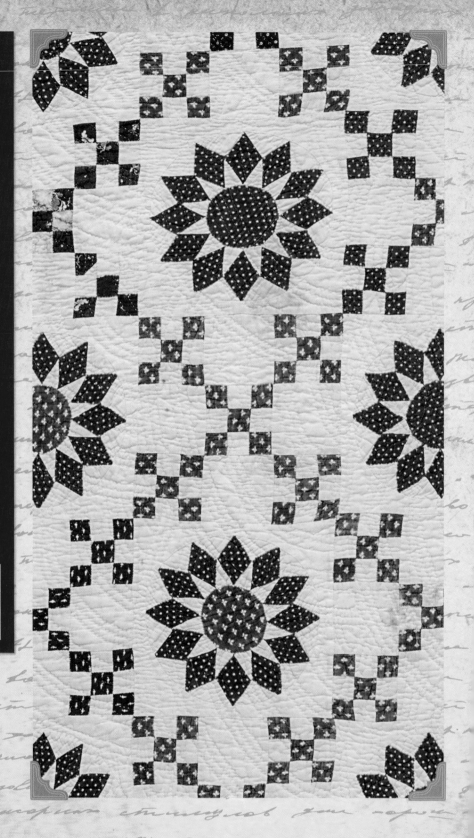

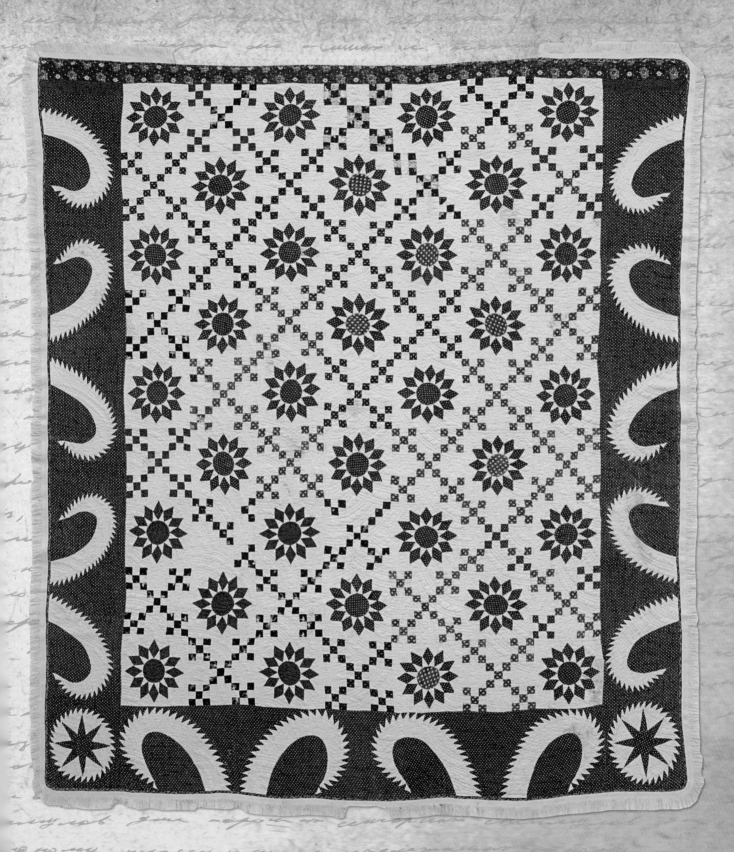

Four-Patch
68" × 78" (c. 1890)

One of the oldest basic patterns, the four-patch, is ideal for using up scraps from dresses, shirts, or whatever fabric you may have around the house. This one features mourning prints and conversation prints with a tattersall check, first created by Richard Tattersall of the United Kingdom. Now, that's not to say that this here fabric came all the way from England, just that once people saw how to make that style of fabric, companies began copying.

This quilt has wonderful scrappy Four-Patch blocks set on point. It includes tattersall-like fabric and a gingham back.

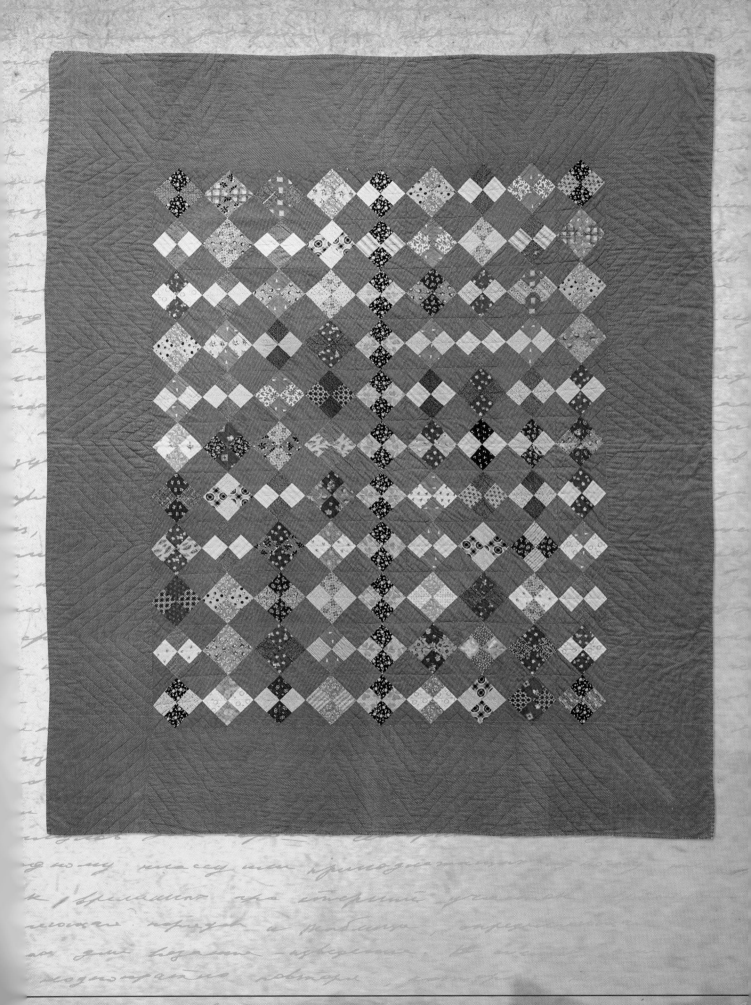

Double Four-Patch Streak of Lightning
72″ × 82″ (c. 1880)

At first glance you might wonder what attracted me to this quilt—until you see the streak of lightning framed by the brown calico. Now I have to say, I've never seen lightning in double pink, but I'd like to think the quilter was watching a thunderstorm during a sunset, and if you squint just right, maybe the lightning was pink. On the plains, a thunderstorm filled with lightning is a memorable reminder of the awesome power of nature.

Using the basic four-patch pattern, this quilter offers a secondary design of "streak of lightning" in double pink.

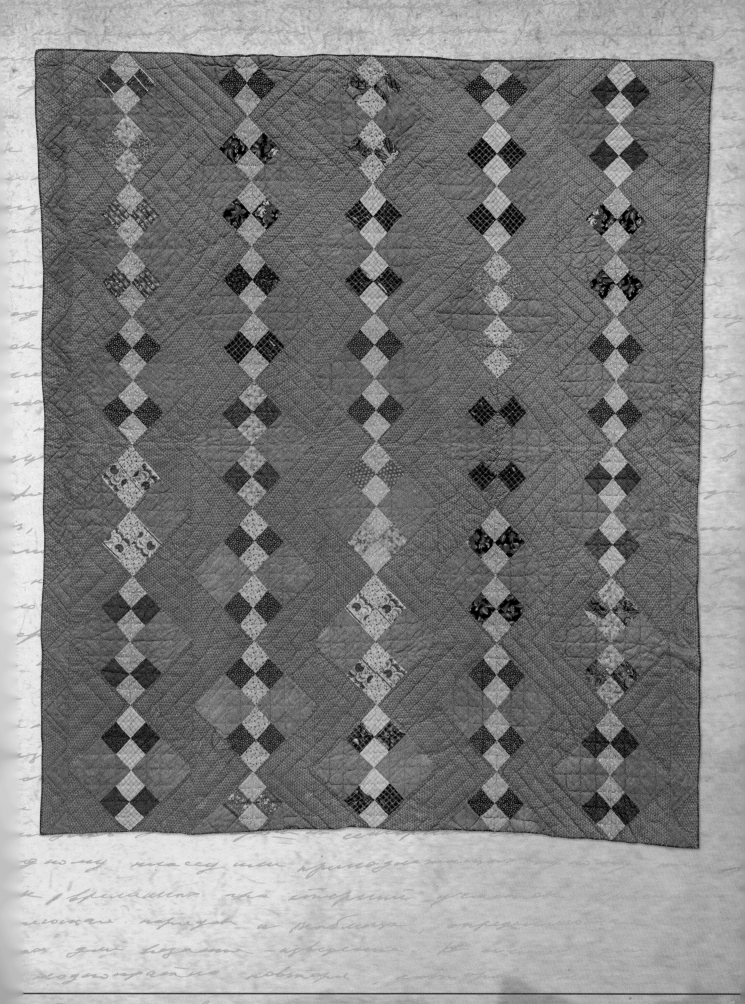

Quarter-Square Triangle Four-Patch
75″ × 75″ (c. 1890)

This quilter used a basic pattern to create a quilt full of mourning prints. It reminded me of the loss of my husband and the etiquette requirement that I wear black for at least a year. Some of the quarter-square triangles are pieced, which could be a repair or relate to frugality. As if the pieces were not small enough, she pieced the pieces. The back gives us another clue to her nature. She didn't quite have enough fabric for the back. But rather than cut up such a large piece of fabric, which would have shown wealth, she chose to frugally piece one corner.

Notice the pink sashing and cornerstones. The back is primarily of one fabric; yet it has also been pieced with one rectangle added in one corner.

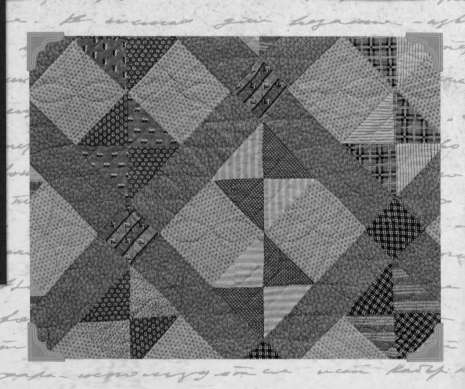

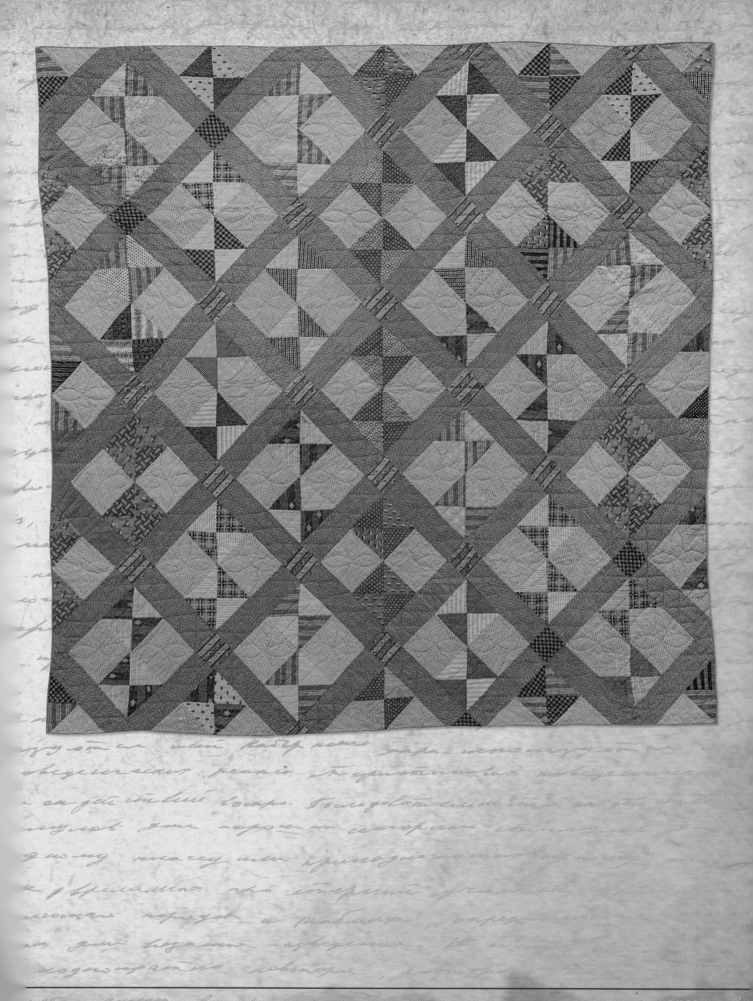

Double Four-Patch Crib Quilt

33" × 42" (c. 1880)

Crib quilts are not usually found in the prairie region because they were frequently reused from child to child until they were worn out. The other reason pioneer crib quilts are rare is because infant mortality for the pioneers was extremely high, and if a baby died, the child would usually be wrapped in a quilt for burial. The four-patch is one of the basic patterns for quilters—many different pattern blocks were created from it.

The block is a Double Four-Patch, with Four-Patch blocks in the cornerstones. Notice the use of indigo-resist fabrics to set off the other colors.

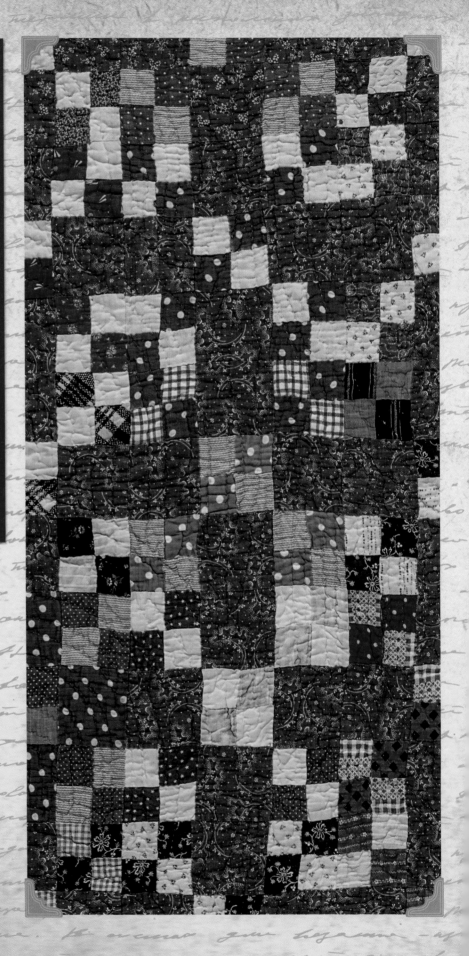

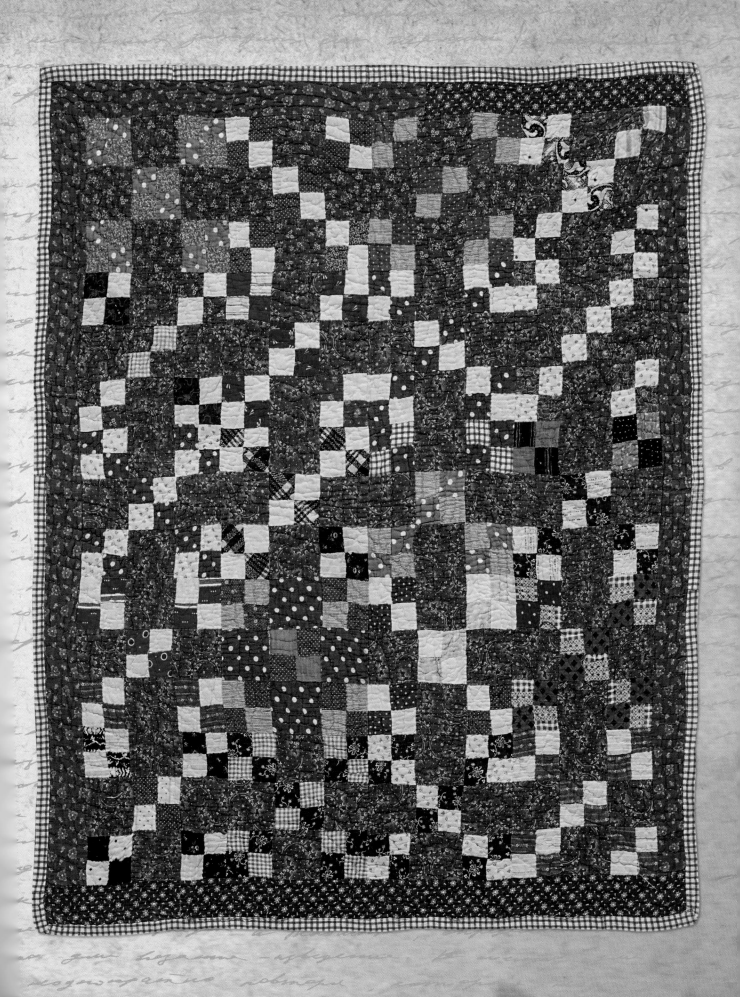

Doll Quilt
18˝ × 20˝ (c. 1890)

Girls on the plains learned their sewing skills at an early age, using small scraps to create quilts like this charming doll blanket. Contained in the Four-Patch are handwoven fabrics—a reminder that you didn't always go into town to purchase fabric at the mercantile or trading post! Sometimes you needed to spin the cotton, weave the fabrics, and then dye them in addition to all your regular chores. On the plains we used a lot of different plants to get the color fabrics we wanted: walnuts, sumac, pokeberries, or bloodroot.

This quilt is made of simple Four-Patch blocks set in diagonal rows.

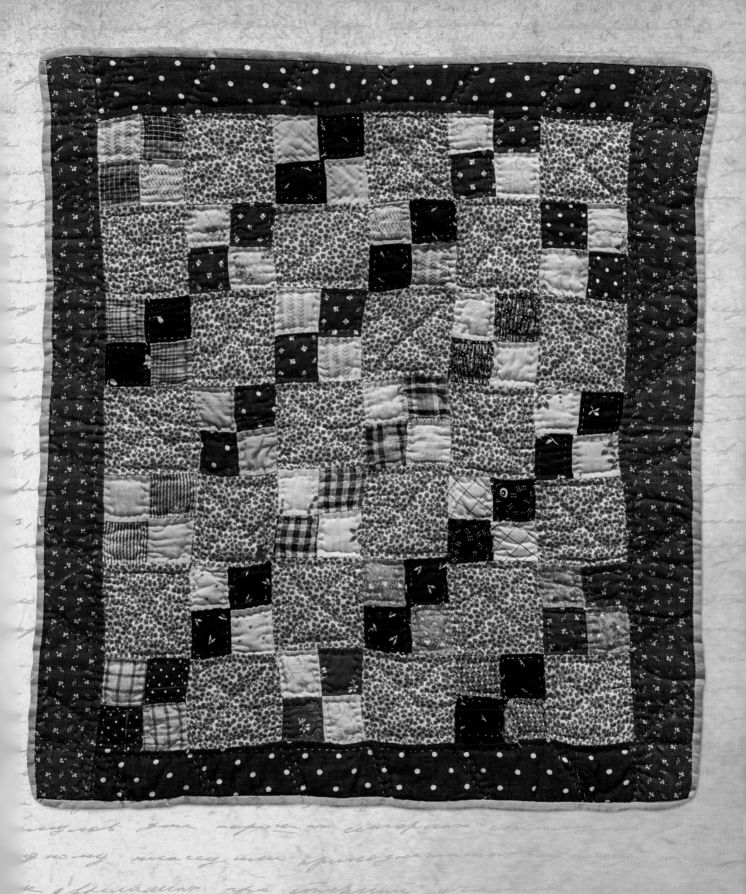

Diamond and Square Crib Quilt
27″ × 36″ (c. 1880)

This quilter had a unique focus for her design, being sure to alternate the double pink diamonds or squares in every direction. She then surrounded the bold details with small piecing to fill out the unique fit. There's deterioration in one of the fabrics from those metals they stick in the dyes to make dark colors.

The same thing happens to your garden hoe when you leave it in the field; it rusts and the paint flakes off.

Notice how the tiny piecing allowed the quilter to alternate between diamonds and squares.

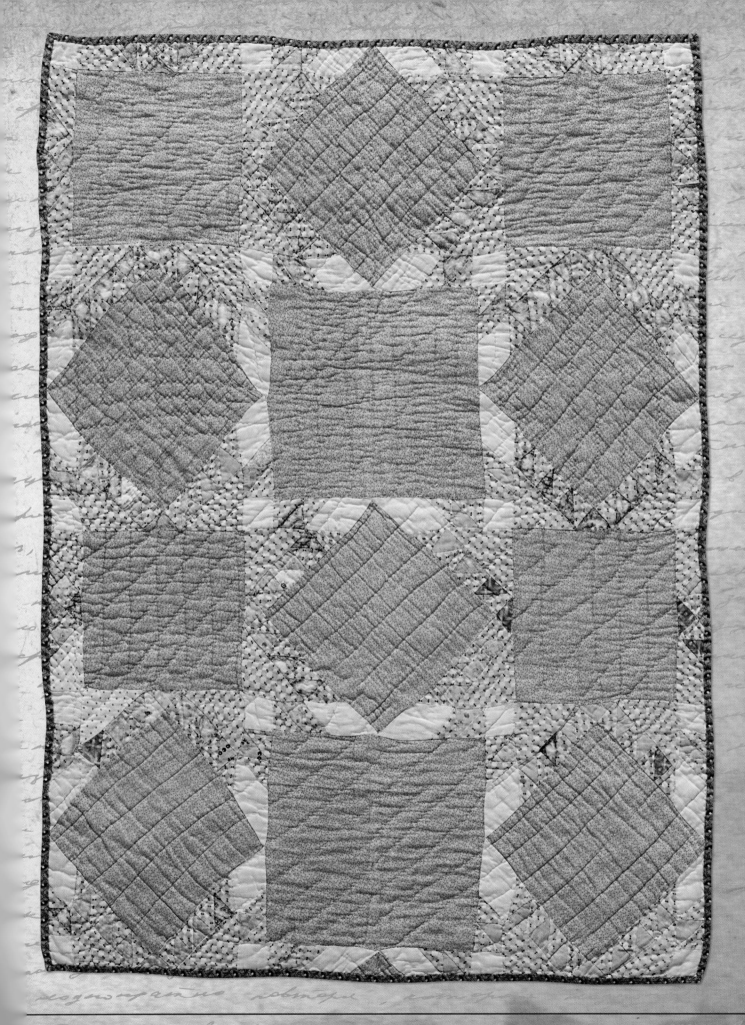

Straight Furrow Quilt
38″ × 48″
(c. 1890)

This quilt was made of fancy fabric and could have been intended as a presentation blanket. New babies were frequently "presented to God" or christened in the faith, and for this occasion they were dressed in special christening gowns and blankets or quilts. These garments and blankets were not used for everyday wear and instead were treasured and saved to be used again for the next child or children of the next generation.

Notice the red squares, which represent where the seed would have been planted. This quilt also has a wonderful pieced back.

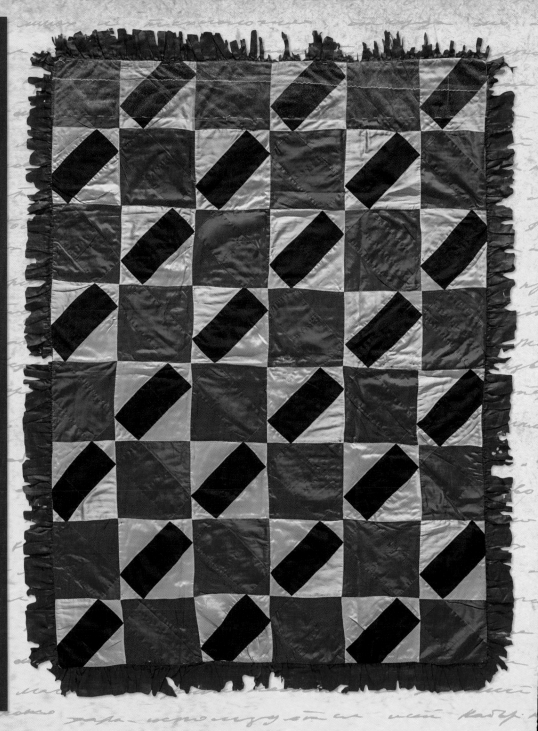

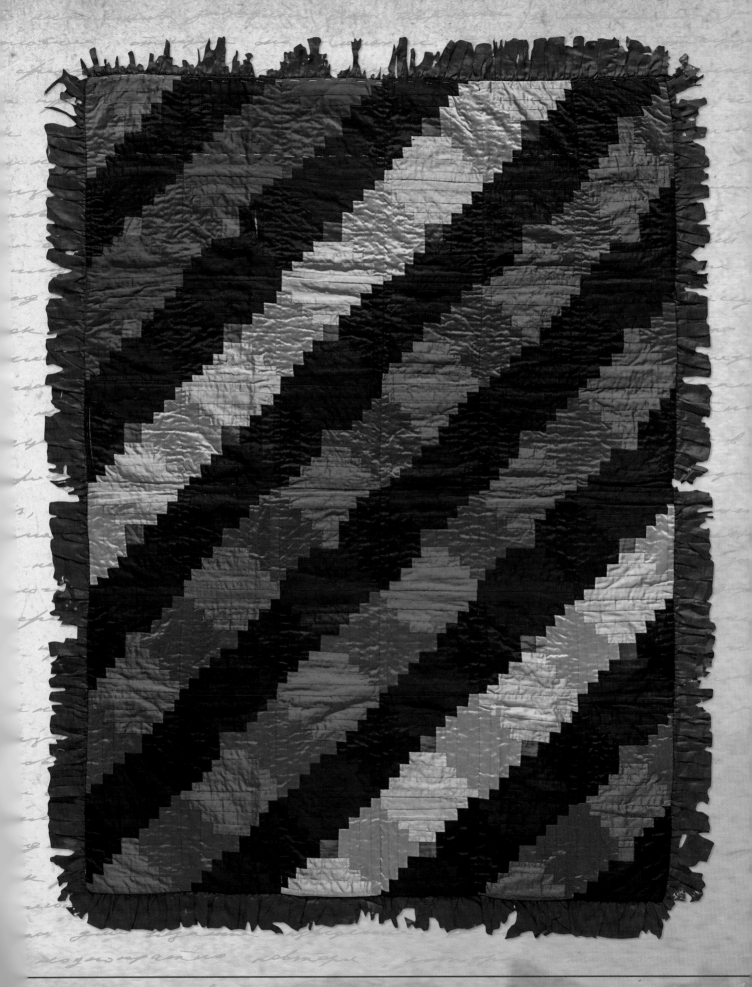

Log Cabin
69″ × 80″ (c. 1880)

The Log Cabin pattern was another common pattern of the plains and a reminder of home. It, too, had multiple variations and was known under a variety of names, including Barn Raising. It also came to have political ramifications. In the fall of 1858, whole communities came together to hear debates between Stephen A. Douglas and Abraham Lincoln. Although women didn't have the right to vote, they could proclaim their allegiance to their favorite politician through their quilts. Douglas was shorter than Lincoln, and the pattern developed for him was called Little Giant. But the man who went on to become president grew up in a log cabin, and this pattern, called Lincoln Logs, became associated with him. President Lincoln would be tasked with leading the United States through the Civil War. The pattern became especially popular after he was assassinated in 1865.

Beautiful brown hues really remind the viewer of wood.

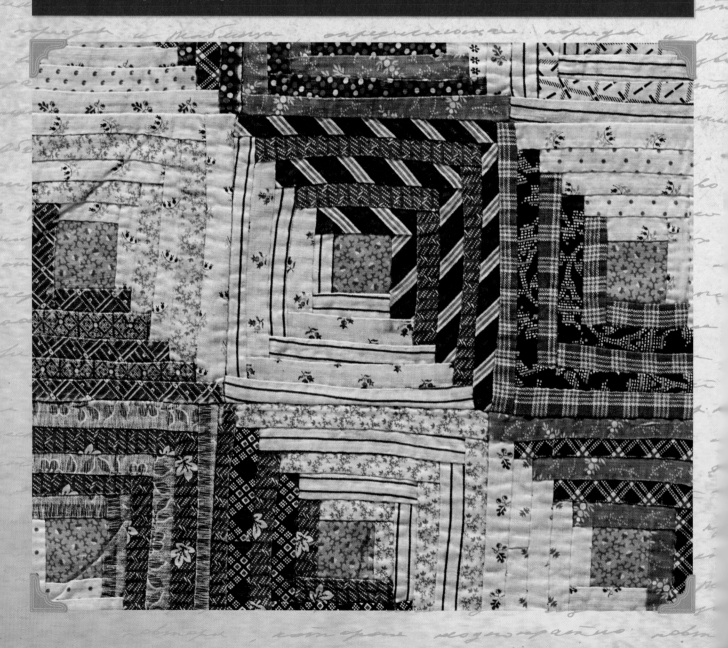

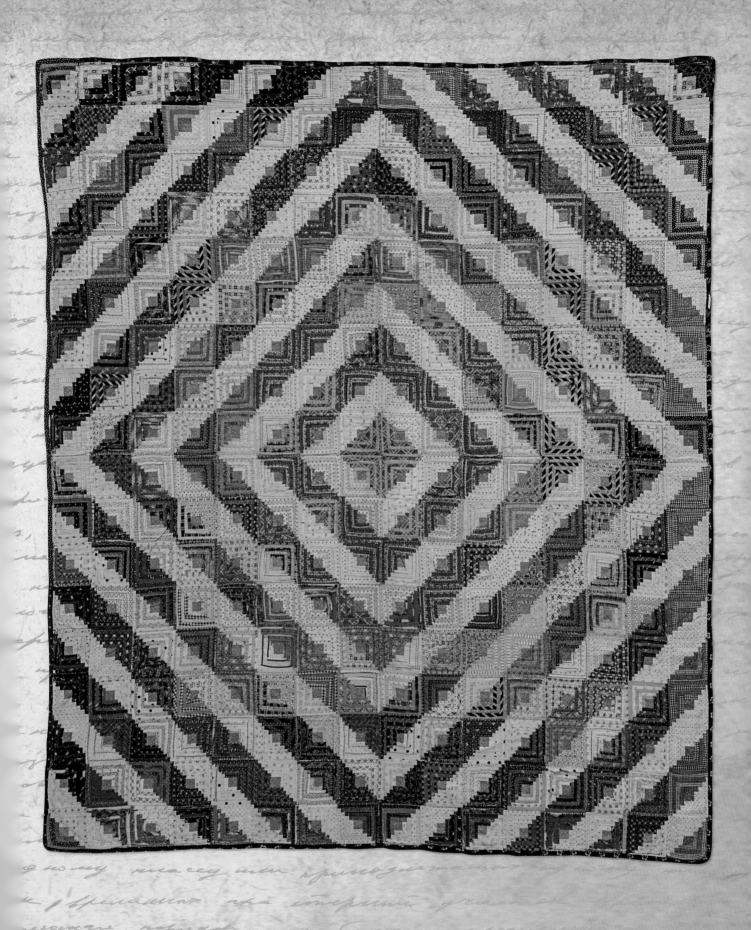

Windmill Blade / Log Cabin
68″ × 80″ (c. 1890)

The Windmill Blade version of Log Cabin is a perfect reminder of how we plains settlers use wind power to pump water for the livestock on the prairie. The invention of the windmill and barbed wire really allowed the plains to be explored and conquered. This quilt is not the type I'd find at a sod house; it is more like an in-town version.

Beautiful red velvet with decorative braid really frames the variety of fabrics. Instead of being quilted, this coverlet is tied and featherstitched.

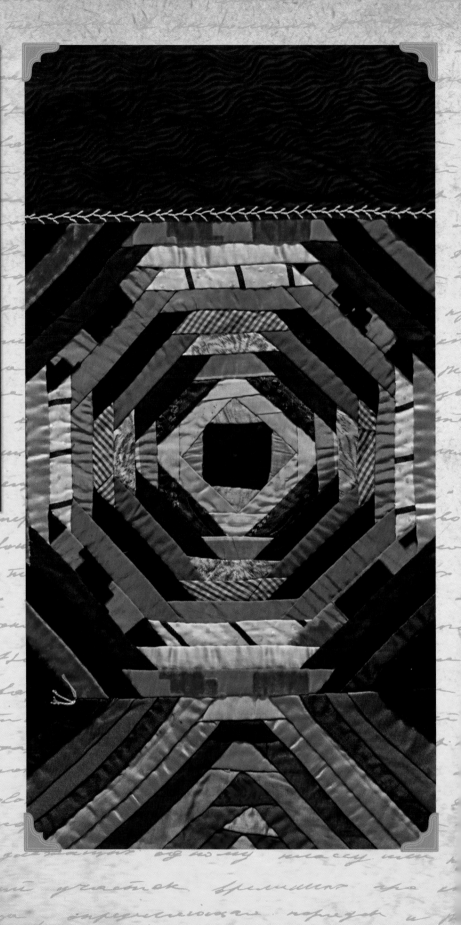

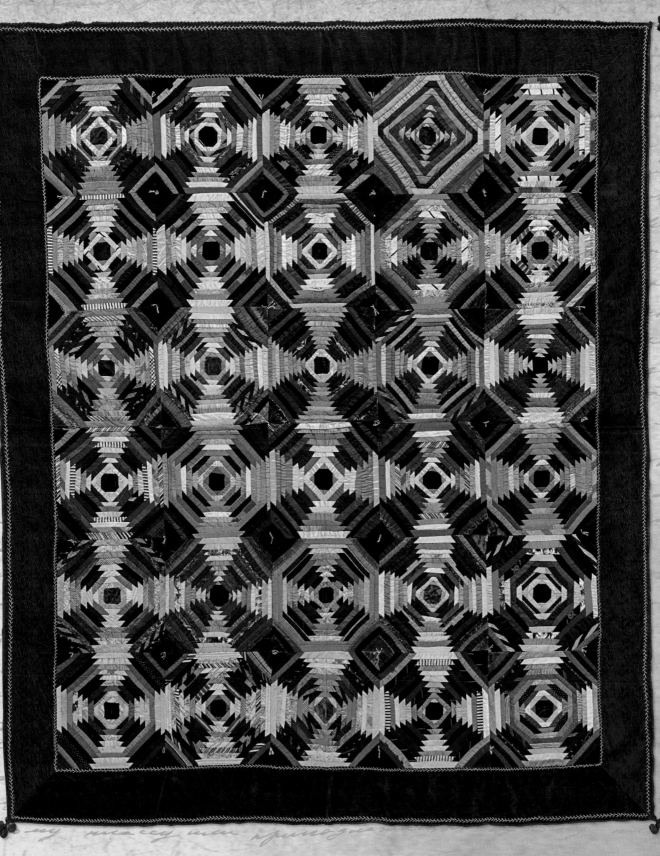

Projects

Each of the antique quilts presented is an example of handmade artistry that was created before the invention of time-saving devices in common use today. We can duplicate the look of these quilts using modern methods to save time on cutting and sewing. Using hundreds of scraps certainly adds charm, but we will use faster techniques to achieve similar results. When possible, we have included quick piecing methods to allow you to duplicate the effect of the antique quilts.

Notes for all projects:

- Fabric requirements are based on 42″ of usable fabric width.

- Maintain an accurate ¼″ seam allowance.

- Bias binding is suggested for all projects except *Double Four-Patch Crib Quilt* (page 91), because the bindings that survived best on the antique quilts were the ones with fabric cut on the bias. Antique quilts often had wide bindings compared with contemporary quilts. The projects call for 3″ bias strips, sewn with a ⅜″ seam. The 3″ strips are folded in half lengthwise to create double-fold binding. The fabric requirements assume that long bias strips are cut from the center outward.

- Borders and sashing are cut on the fabric width and pieced as needed.

- The projects use basic shapes such as squares and triangles, but an intermediate skill level will be helpful. For a review of the fundamentals, see volumes 1 and 2 of the Quilter's Academy series by C&T Publishing. Volume 3 provides techniques for piecing with precision, which is needed for making *Delectable Mountains* (next page) and *Wild Goose Chase* (page 80).

- Batting should be cut to 8″ larger in both width and length, allowing 4″ on all sides.

Delectable Mountains (c. 1850)

FINISHED SIZE: 101″ × 101″

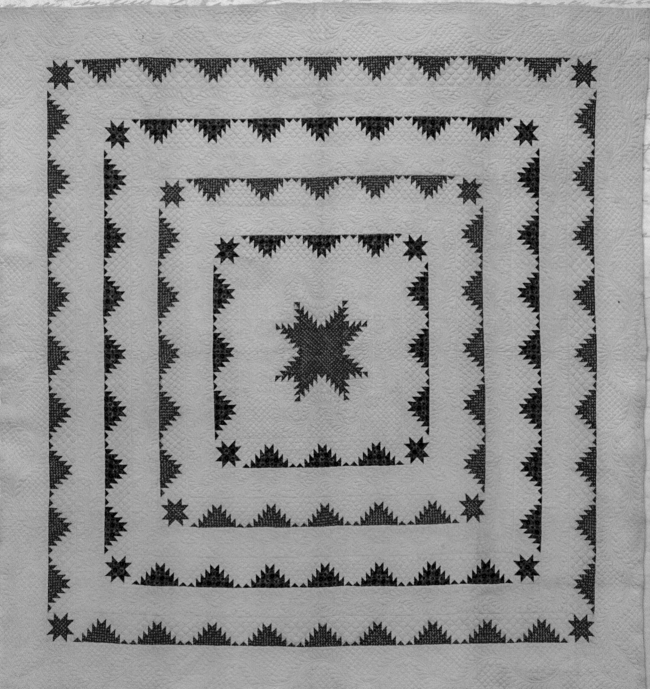

For more information on this quilt, see Esther Heinzmann Tells Tales of the Prairie through Quilts, Delectable Mountains (page 16).

Fabric Requirements

Cream: 10⅛ yards for blocks and binding

Red: 2⅛ yards for blocks

Green: 1¼ yards for blocks

Backing: 9⅛ yards

Batting: Standard King-size batting, 120″ × 120″

Cutting

FS = Feathered Star • DM = Delectable Mountain • VS = Variable Star

CREAM

- ❊ 4 squares 4½″ × 4½″ for FS block
- ❊ 1 square 9⅞″ × 9⅞″ cut on both diagonals for FS block
- ❊ 7 squares 4″ × 4″ for half-square triangles in FS block
- ❊ 4 squares 1¹³⁄₁₆″ × 1¹³⁄₁₆″ cut diagonally for FS block
- ❊ 4 squares 1⅞″ × 1⅞″ cut diagonally for FS block
- ❊ 96 squares 1½″ × 1½″ for DM blocks
- ❊ 96 squares 4″ × 4″ for half-square triangles in DM blocks
- ❊ 20 squares 9¾″ × 9¾″ cut on both diagonals for DM borders
- ❊ 16 squares 5⅛″ × 5⅛″ cut diagonally for DM borders
- ❊ 64 squares 1⁹⁄₁₆″ × 1⁹⁄₁₆″ for VS blocks
- ❊ 64 rectangles 1⁹⁄₁₆″ × 2⅝″ for VS blocks
- ❊ 3 strips 5″ × width of fabric for borders
- ❊ 17 strips 4¾″ × width of fabric for borders
- ❊ 10 strips 8½″ × width of fabric for borders
- ❊ 3″ bias strips for binding

RED

- ❊ 1 square 7″ × 7″ for FS block
- ❊ 4 squares 3⅝″ × 3⅝″ cut diagonally for FS block
- ❊ 7 squares 4″ × 4″ for half-square triangles in FS block
- ❊ 4 squares 1½″ × 1½″ for FS block
- ❊ 2 squares 1¹³⁄₁₆″ × 1¹³⁄₁₆″ cut diagonally for FS block
- ❊ 56 squares 4″ × 4″ for half-square triangles in DM blocks
- ❊ 14 squares 7″ × 7″ cut on both diagonals for DM blocks
- ❊ 56 squares 1⅞″ × 1⅞″ cut diagonally for DM blocks
- ❊ 8 squares 2⅝″ × 2⅝″ for VS blocks
- ❊ 64 squares 1⁹⁄₁₆″ × 1⁹⁄₁₆″ for VS blocks

GREEN

- ❊ 40 squares 4″ × 4″ for half-square triangles in DM blocks
- ❊ 10 squares 7″ × 7″ cut on both diagonals for DM blocks
- ❊ 40 squares 1⅞″ × 1⅞″ cut diagonally for DM blocks
- ❊ 8 squares 2⅝″ × 2⅝″ for VS blocks
- ❊ 64 squares 1⁹⁄₁₆″ × 1⁹⁄₁₆″ for VS blocks

Making Half-Square Triangle Units 8 at a Time

This method yields 8 half-square triangle units from each pair of 4″ × 4″ squares.

1. Place 1 cream square and 1 red square 4″ × 4″ right sides together. Draw diagonals as shown.

2. Sew ¼″ from each side of both diagonal lines. Cut as shown in red.

3. Cut on the diagonals.

4. Press the seam allowances open to reduce bulk.

5. Follow Steps 1–4 to make 448 cream/red half-square triangles for the Delectable Mountain blocks. Trim to 1½″ × 1½″.

6. Follow Steps 1–4 to make 56 cream/red half-square triangles for the Feathered Star block. Trim 24 of these to 1½″ × 1½″. Trim the remaining 32 using the template.

Feathered Star HST Cut 32.

The finished half-square triangles for the diagonal unit in the Feathered Star are slightly under 1″.

tip *This quilt uses hundreds of half-square triangles, most for the Delectable Mountain blocks and some for the Feathered Star. The 32 slightly smaller half-square triangles are for the Feathered Star. Keep them separate to avoid confusion.*

7. Follow Steps 1–4 to make 320 cream/green half-square triangles for the Delectable Mountain blocks.

Feathered Star Block Assembly

1. Sew together 3 half-square triangles 1½″ × 1½″ as shown. Add a cream half-square triangle (cut from a 1⅞″ × 1⅞″ square). Press the seams open.

2. Create another unit, reversing the direction of the triangles, and add a red square 1½″ × 1½″. Press the seams open.

3. Add the half-square triangle units to a cream square 4½″ × 4½″. Press toward the cream square. Make 4.

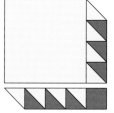

Make 4 for the corners of the Feathered Star.

4. Sew together 4 half-square triangles of the smaller-size triangles, as shown. This unit should measure 4¼″ wide. Add a cream half-square triangle (cut from a 1¹³⁄₁₆″ × 1¹³⁄₁₆″ square). Join this unit to a red half-square triangle (cut from a 3⅝″ × 3⅝″ square). The red half-square triangle is slightly oversized, so trim as needed. Press toward the red triangle.

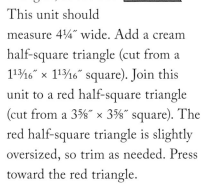

5. Create another unit, reversing the direction of the triangles. Then add a red half-square triangle (cut from a 1¹³⁄₁₆″ × 1¹³⁄₁₆″ square). Press toward the red triangle.

6. Take the unit from Step 4 and add a cream quarter-square triangle (cut from a 9⅞″ × 9⅞″ square) using a partial seam. Add the unit from Step 5, again using a partial seam. Make 4.

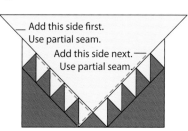

 Add this side first. Use partial seam. Add this side next. Use partial seam.

Make 4 for the sides of the Feathered Star.

> ❊ **note** ❊
>
> Be sure to use a quarter-square triangle for the large cream triangle. This places the straight grain at the outside.

7. Add corner units from Step 3. Finish the partial seams as shown. Press toward the large cream triangle. Make 2.

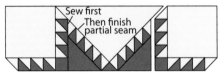

Make 2 for the top and bottom row of the Feathered Star.

8. The star will be assembled in rows. Sew the 2 remaining sides from Step 6 to the red square 7″ × 7″ to form the middle row. Sew the rows, finishing partial seams as needed. Trim to 17″ × 17″.

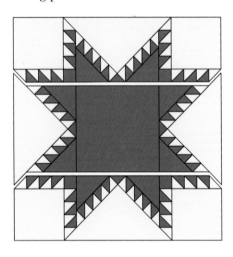

Delectable Mountains Block Assembly

1. Sew together 4 half-square triangles as shown, and add a red half-square triangle (cut from a 1⅞″ × 1⅞″ square). Sew another unit, reversing the triangles as shown. Add a cream square 1½″ × 1½″.

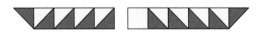

2. Add these units to a quarter-square triangle (cut from a 7″ × 7″ square). Make a total of 56 red blocks and 40 green blocks.

Variable Star Block Assembly

1. Using cream rectangles 1⁹⁄₁₆″ × 2⅝″ and color squares 1⁹⁄₁₆″ × 1⁹⁄₁₆″, make Flying Geese using the method described in *Wild Goose Chase* (page 80). Make 32 red Flying Geese and 32 green Flying Geese.

2. Using a center square 2⅝″ × 2⅝″, 4 cream squares 1⁹⁄₁₆″ × 1⁹⁄₁₆″, and 4 Flying Geese units, piece 3 rows. Sew the rows to make the Variable Star block. Make a total of 8 red blocks and 8 green blocks.

Construction

The quilt is assembled from the center out by adding plain borders alternating with Delectable Mountain (DM) borders, using Variable Stars as cornerstones.

1. Add cream borders 5″ × 17″ to both sides of the Feathered Star. Add cream borders 5″ × 26″ to the top and bottom.

❧ *note* ❧

In general, the actual quilt should be measured to determine border lengths. For this quilt, however, it's important to stay close to the calculated lengths so that the next pieced border will fit. Adjust or ease as needed from the center out.

2. Add cream quarter-square triangles (cut from a 9¾″ × 9¾″ square) to create the border strip of DMs. Begin and end with cream half-square triangles (cut from 5⅛″ squares).

Make 4.

3. Add DM pieced borders to each side of the quilt.

4. To each end of the remaining 2 borders, add a Variable Star block to form cornerstones.

5. Add borders with cornerstones to the top and bottom.

6. Alternate adding plain and pieced borders, using the lengths in the quilt assembly diagram to complete the quilt top.

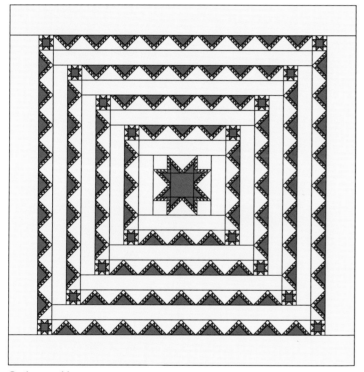

Quilt assembly

note about borders

Grow the borders as follows:

First DM border: 3 green DM blocks per side

Second cream border: 4¾″ × 34½″; 4¾″ × 43″

Second DM border: 5 red DM blocks per side

Third cream border: 4¾″ × 51½″; 4¾″ × 60″

Third DM border: 7 green DM blocks per side

Fourth cream border: 4¾″ × 68½″; 4¾″ × 77″

Fourth DM border: 9 red DM blocks per side

Outer cream border: 8½″ × 85½″; 8½″ × 102″

Finishing

1. Sew widths of backing fabric together. Then layer the batting and backing under the top, and baste or pin as needed. Quilt as desired.

2. Cut 3″ bias strips from the cream fabric. Sew the strips together until the binding strip measures 420″. Starting at the bottom of the quilt, attach the binding, following your preferred method. Use a ⅜″ seam allowance.

Wild Goose Chase (c. 1875)

FINISHED SIZE: 72″ × 83″

For more information on this quilt, see Esther Heinzmann Tells Tales of the Prairie through Quilts, Wild Goose Chase (page 28).

Fabric Requirements

Cream: 2¼ yards for blocks and borders

Brown prints: a variety of fabrics totaling 2⅛ yards for blocks and borders

Red print: 1½ yards for blocks

Green print: 2¼ yards for alternate blocks

White floral print: ⅛ yard for border

Gold: 1 yard for 3″ bias binding

Backing: 5 yards

Batting: 80″ × 88″

Cutting

CREAM

- 672 squares 1⅝″ × 1⅝″ for blocks and borders
- 112 squares 2″ × 2″ cut on diagonal for blocks
- 46 squares 4″ × 4″ cut on both diagonals for border

BROWN PRINTS

- 112 squares 2⅛″ × 2⅛″ for block corners
- 28 squares 2¾″ × 2¾″ for block centers
- 336 rectangles 1⅝″ × 2¾″ for Flying Geese
- 91 squares 2½″ × 2½″ for borders

RED PRINT

- 28 squares 7¾″ × 7¾″ cut on both diagonals for blocks

GREEN PRINT

- 28 squares 10″ × 10″

WHITE FLORAL PRINT

- 2 strips 2″ × width of fabric

GOLD

- 3″ strips cut on the bias for binding

Block Assembly

Wild Goose Chase Blocks

1. Choose 1 brown print rectangle 1⅝″ × 2¾″ and 2 cream squares 1⅝″ × 1⅝″. Lightly draw a diagonal line on the wrong sides of the squares.

2. With right sides together, place a square on one end of the rectangle. Sew directly on the line, and trim the seam allowance to ¼″.

3. Press open.

4. With right sides together, place the other square on the other end of the rectangle. Sew directly on the line, trim the seam allowance to ¼″, and press open.

5. Make 12 Flying Geese units for each block.

6. Sew 3 Flying Geese units together. Make 4 units per block.

Three Flying Geese

7. Choose a brown print square 2⅛″ × 2⅛″ and sew 2 cream triangles (cut on the diagonal from the 2″ × 2″ squares) to 2 adjacent sides. Sew this unit to the left of the 3 Flying Geese units, as shown.

Add the block corner. Make 4 units per block.

8. Lay out and sew the block center as shown, with a brown print 2¾˝ × 2¾˝ square.

Assemble the block center.

9. Sew the red print triangles to the Flying Geese units. Sew the resulting units together in diagonal rows. The corner squares are slightly oversized, so trim the block to 10˝ × 10˝.

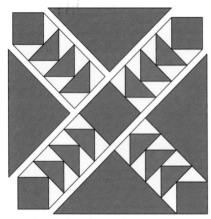

Sew the block in diagonal rows.

10. Repeat Steps 1–9 to make a total of 28 Wild Goose Chase blocks.

Construction

1. Alternate the Wild Goose Chase blocks and the green print blocks, 7 blocks to a row.

2. Make 8 rows. Sew the rows together.

3. Sew the white floral strip border to the top.

4. Create 3 diamond borders, using 2¼˝ × 2¼˝ squares set in cream triangles. Make 2 borders with 31 diamonds and 1 border with 29 diamonds. You might have additional triangles at the ends of the borders. Measure and trim if necessary.

❧ *note* ❧

If you choose to make the border diamonds out of the same fabric, a Seminole strip-piecing method could be used instead, as described in *Indigo Quilts* (by C&T Publishing).

5. Sew the borders with 31 diamonds to the sides of the quilt.

6. Sew the border with 29 diamonds to the bottom.

Three sides have pieced borders, and a strip is used at the top.

Finishing

1. Sew widths of backing fabric together. Then layer the batting and backing under the top, and baste or pin as needed. Quilt as desired.

2. Cut 3˝ bias strips from the gold fabric. Sew the strips together until the binding strip measures 320˝. Starting at the bottom of the quilt, attach the binding, following your preferred method. Use a ⅜˝ seam allowance.

Cake Stand (c. 1890)

FINISHED SIZE: 57″ × 70″

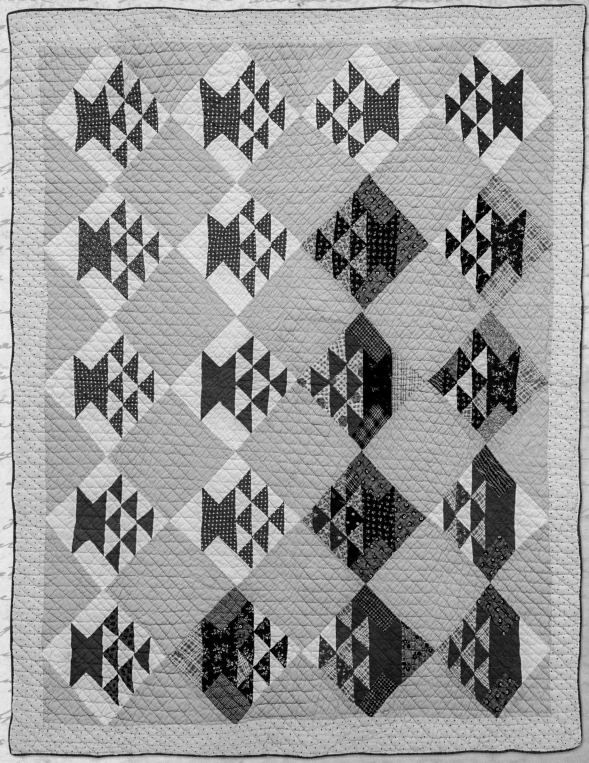

For more information on this quilt, see Esther Heinzmann Tells Tales of the Prairie through Quilts, Cake Stand (page 46).

Fabric Requirements

Cream or light-colored scraps: 1 yard for blocks

Red prints: 1½ yards for blocks and binding

Scrap prints: totaling 1⅛ yards

Red-and-white stripe: 2⅛ yards for alternate blocks and setting triangles

Pink polka dot: ⅞ yard for borders

Backing: 3¾ yards

> ### note
>
> These fabric amounts assume that 9 Cake Stand blocks are sewn with scraps to reproduce the improvisational look of the original. Note that several scrap blocks in the original used red and cream pieces; we did not count those pieces in the amounts for red prints and cream.
>
> If you want to make all the Cake Stand blocks without using scraps, increase the red prints amount to 2⅛ yards and cream or light-colored scraps to 1⅝ yards.

Cutting

CREAM OR LIGHT-COLORED SCRAPS

- ❀ 11 squares 6¼″ × 6¼″ •
- ❀ 6 squares 5⅜″ × 5⅜″
- ❀ 22 rectangles 2¾″ × 5″

RED PRINTS

- ❀ 11 squares 6¼″ × 6¼″
- ❀ 6 squares 5⅜″ × 5⅜″
- ❀ 3″ bias strips for binding

SCRAP PRINTS

- ❀ 18 squares 6¼″ × 6¼″
- ❀ 10 squares 5⅜″ × 5⅜″
- ❀ 18 rectangles 2¾″ × 5″

RED-AND-WHITE STRIPE

- ❀ 12 squares 9½″ × 9½″
- ❀ 4 squares 14″ × 14″ cut on both diagonals for side setting triangles (2 extra)
- ❀ 2 squares 7¼″ × 7¼″ cut diagonally for corner setting triangles

PINK POLKA DOT

- ❀ 7 strips 3½″ × width of fabric for borders

Block Assembly

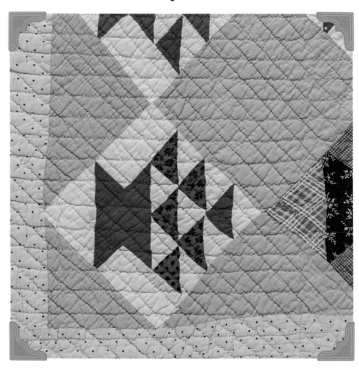

The original quilt was hand pieced using a large collection of triangles. Cutting the triangles *before* sewing is a difficult way to make half-square triangles, as the bias edges are very stretchy. It is apparent that the quiltmaker had lots of issues that add to the folksy feel of the quilt. She simply cut the block to size and didn't worry about cutting off points. Piecing the half-square triangles with scraps is an excellent way to use your stash, and it makes for a portable project—but it isn't the fastest or most accurate method.

tips

View the Cake Stand block as a Four-Patch to see how it is put together: 1 quadrant with 4 half-square triangles, 2 quadrants with half-square triangles and rectangles for the sides, and a larger half-square triangle for the base. Keep this structure in mind to help with placement of triangles. The original was hand pieced, but with today's techniques this quilt can be a quick-and-easy baby quilt.

View the block as a Four-Patch.

There are many methods for creating half-square triangles. As shown in Delectable Mountains *(page 75), we can create 8 at a time. This method is convenient for this block, since each Cake Stand block has 8 half-square triangles.*

For the large half-square triangle, which forms the base, we use a method that creates 2 at a time. Both methods keep the bias edge stable because the triangles are cut after sewing. *For smaller scraps, feel free to use your own method.*

1. Place a red print square 6¼˝ × 6¼˝ and a cream/light square 6¼˝ × 6¼˝ right sides together. Follow the steps to create 8 half-square triangles (page 77).

2. Trim the half-square triangles to 2¾˝ so the diagonal seams will align when sewn.

3. Sew 4 half-square triangles together into a square unit.

4. Use the 4 remaining half-square triangles to make pairs for the left and right side of the Cake Stand. Sew these pairs to the rectangles 2¾˝ × 5˝ to create 2 more units. Check the direction of the triangles as you sew.

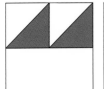

Block layout

5. Place a red print square 5⅜˝ × 5⅜˝ and a cream/light square 5⅜˝ × 5⅜˝ right sides together.

Draw a diagonal on the wrong side of the cream/light square. Sew ¼˝ from each side of the diagonal. Cut on the diagonal to create 2 half-square triangles. (Set 1 aside for another block.)

6. Using the units from Steps 3–5, sew the 4 quadrants together, creating a Cake Stand block.

7. Repeat Steps 1–6 to make a total of 20 Cake Stand blocks, with 9 made from scrap prints.

❧ *note* ❧
You will have 1 additional red print Cake Stand and 1 additional scrap print Cake Stand.

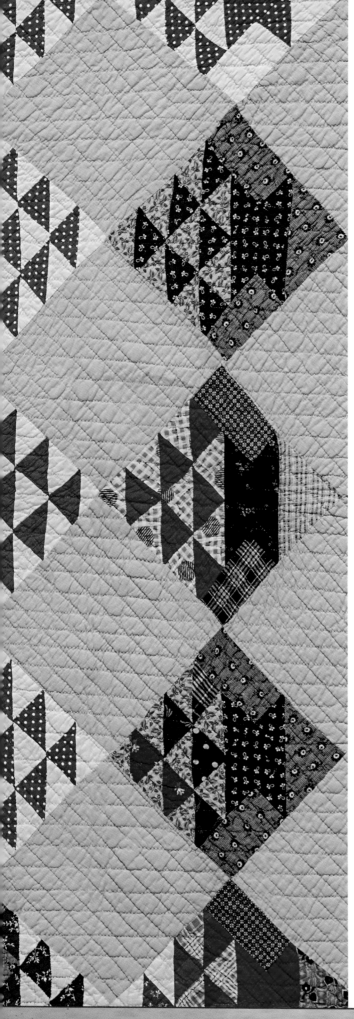

Construction

1. Arrange the Cake Stand blocks, plain blocks, and setting triangles. Intersperse the blocks with scrap prints.

2. Sew each diagonal row of blocks together, adding setting triangles as shown. Sew the rows together.

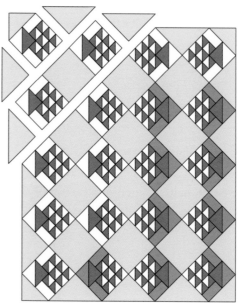

Assemble the quilt using diagonal rows.

3. Sew 3½″ borders on each side. Sew 3½″ borders to the top and bottom.

Finishing

1. Sew widths of backing fabric together. Then layer the batting and backing under the top, and baste or pin as needed. Quilt as desired.

2. Cut 3″ bias strips from the red print fabric. Sew the strips together until the binding strip measures 270″. Starting at the bottom of the quilt, attach the binding, following your preferred method. Use a ⅜″ seam allowance.

Red-and-White Nine-Patch (c. 1870)

FINISHED SIZE: 85″ × 85″

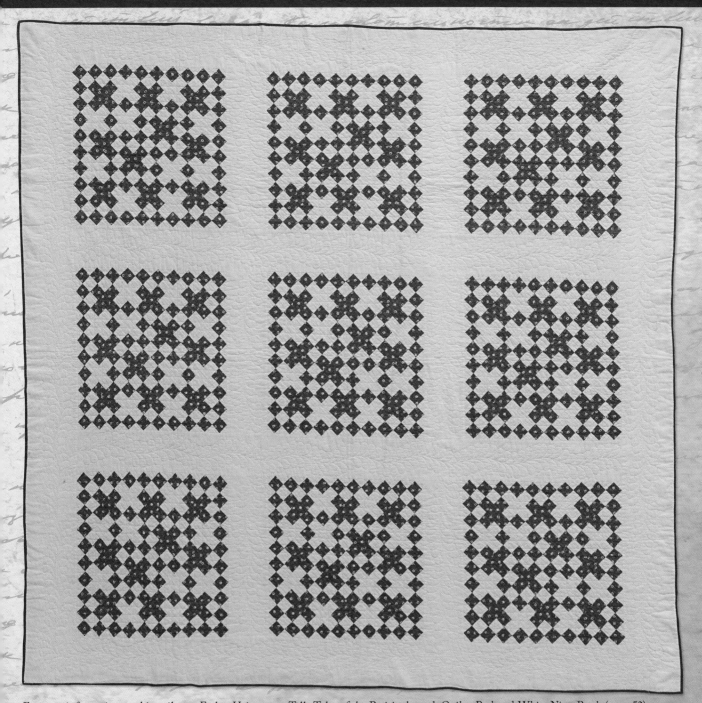

For more information on this quilt, see Esther Heinzmann Tells Tales of the Prairie through Quilts, Red-and-White Nine-Patch (page 52).

White: 5¾ yards for blocks and sashing

Red print: 3¾ yards for blocks and binding

Backing: 7⅞ yards

Cutting

WHITE

- 24 strips 2″ × width of fabric

- 5 strips 5″ × width of fabric

- 18 squares 2″ × 2″ cut diagonally for corner setting triangles

- 81 squares 3⅜″ × 3⅜″ cut on both diagonals for side setting triangles

- 6 strips 5¼″ × 22″ cut along the length of fabric for sashing

- 4 strips 5¼″ × width of fabric for sashing

- 9 strips 6½″ × width of fabric for borders, subcut into:

 2 strips 6½″ × 73¾″

 2 strips 6½″ × 85¾″

> ### ❋ *note* ❋
> Border sizes are given for reference, but strips should be cut only after measuring the actual quilt. The small pieces in the 9 large blocks are difficult to piece precisely.

RED PRINT

- 33 strips 2″ × width of fabric

- 5 strips 5″ × width of fabric

- 3″ bias strips for binding

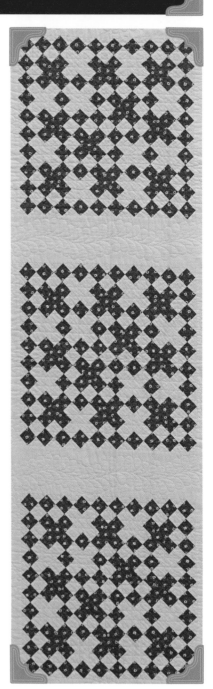

Block Assembly

At first glance the block design appears to contain a basic nine-patch with red and white crosses on a grid of nine squares. Closer examination reveals that the design is quite complicated. Like the other quilts from the mid-1800s, it is hand pieced, one piece at a time. When a red cross is examined, it becomes apparent that it overlays the neighboring white cross. The centers of the nine-patch are rectangles rather than three squares, so Y-seams or partial seams might have been used to join the blocks.

Y-seams or partial seams may have been used to join crosses.

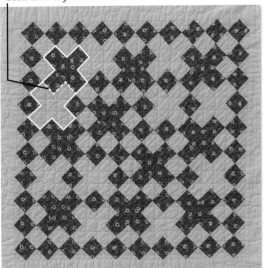

The centers of the crosses are a rectangle, so Y-seams or partial seams may have been used in the original.

If we view the block diagonally, we see a better way of constructing it: row by row.

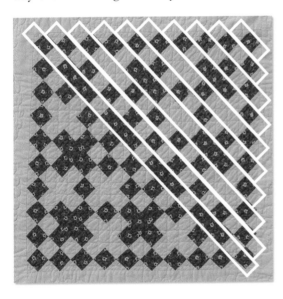

1. Create the following strips sets.

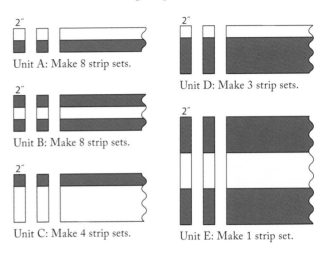

2″
Unit A: Make 8 strip sets.

2″
Unit B: Make 8 strip sets.

2″
Unit C: Make 4 strip sets.

2″
Unit D: Make 3 strip sets.

2″
Unit E: Make 1 strip set.

> ❧ *note* ❧
>
> These strip sets are enough to make all 9 large blocks. Rather than sewing all the strip sets before proceeding, you may want to make 1 of each strip set and then sew 1 block to see how the design comes together.

2. Subcut the strip sets into 2″-wide units. Sew the units into rows, as shown.

> ❧ *note* ❧
>
> The block design has diagonal symmetry. After row 10, the design is mirrored, so each row (except row 10) is needed twice per block.

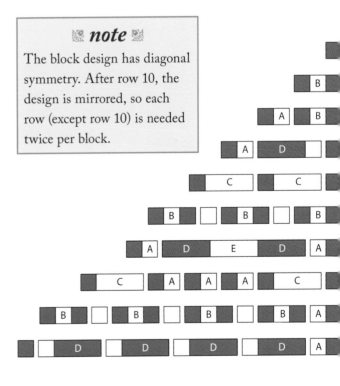

3. Add the side setting triangles. Sew the rows together. Add the corner setting triangles.

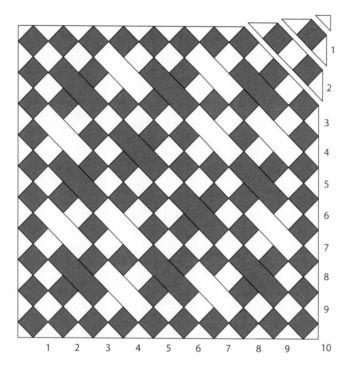

4. Trim the large block to 21¾″ × 21¾″, making sure to leave a ¼″ seam allowance in the white setting triangles.

5. Repeat Steps 2–4 to create a total of 9 large blocks.

Construction

1. Sew a large block to the right and left of white sashing strip 5¼″ × 22″.

> ### ❧ *note* ❧
> Lengths are given for the borders and sashing, but measure the actual quilt top before cutting. Calculated lengths are provided so that you can aim to keep the quilt square.

2. Sew a sashing strip to the right of the second block and then add another block to form a row of 3 large blocks with sashing in between.

3. Repeat Steps 1–2 to make 3 rows.

4. Piece together 2 long sashing strips 5¼″ × 73¾″. Again, measure your quilt before cutting.

5. Sew the long sashing strips between the rows.

6. Piece 2 borders 6½″ × 73¾″, measuring before cutting.

7. Add the borders to each side of the quilt top.

8. Measure for the final 2 borders 6½″ × 85¾″. Piece the borders and add them to the top and bottom.

Finishing

1. Sew widths of backing fabric together. Then layer the batting and backing under the top, and baste or pin as needed. Quilt as desired.

2. Cut 3″ bias strips from the red print fabric. Sew the strips together until the binding strip measures 360″. Starting at the bottom of the quilt, attach the binding, following your preferred method. Use a ⅜″ seam allowance.

Double Four-Patch Crib Quilt (c. 1880)

FINISHED SIZE: 34½″ × 42″

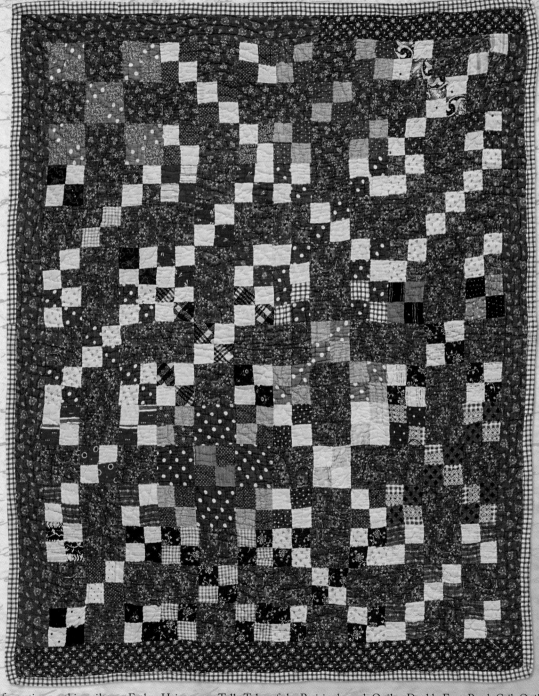

For more information on this quilt, see Esther Heinzmann Tells Tales of the Prairie through Quilts, Double Four-Patch Crib Quilt (page 62).

Indigo-resist or blue prints: 1 yard for nine-patch alternate squares and border

Dark prints: ⅝ yard for four-patches

White or light prints: ⅝ yard for four-patches

Red gingham: ½ yard for straight-grain binding

White fabric: 1½ yards for backing

Cutting

INDIGO-RESIST OR BLUE PRINTS

- 80 squares 3″ × 3″ for setting squares
- 4 strips 2½″ × width of fabric for borders

DARK PRINTS

- 10 strips 1¾″ × 18″

WHITE OR LIGHT PRINTS

- 10 strips 1¾″ × 18″

> ✿ *note* ✿
>
> Each Nine-Patch block contains 5 four-patches. In most of the blocks, the original quiltmaker used the same 2 fabrics within each Nine-Patch. To make 1 Nine-Patch block, 2 strips 1¾″ × 18″ are enough. For the modern quilter, this means 18″ strips from fat quarters would be perfect for this quilt.

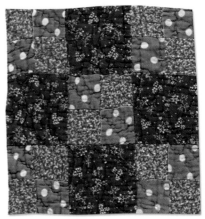

Most of the Nine-Patch blocks use the same 2 fabrics for the four-patches.

Block Assembly

1. Place 2 strips 1¾″ × 18″ right sides together, 1 light and 1 dark. Sew lengthwise to make a strip set.

2. Subcut the strip set into 1¾″-wide units.

3. Sew 2 units together to make a four-patch. Make 5 four-patches for each Nine-Patch block.

4. Join the four-patches with blue setting squares 3″ × 3″ to make the Nine-Patch block.

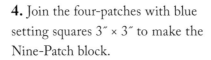

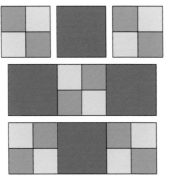

Nine-Patch block made up of four-patches

5. Repeat Steps 1–4 to make a total of 20 Nine-Patch blocks.

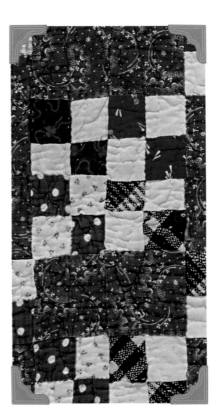

Construction

1. Sew 4 Nine-Patch blocks together to make a row. Make 5 rows. Sew the rows together.

2. Sew 2½″ × 38″ border strips to each side. Sew 2½″ × 34½″ border strips to the top and bottom.

note

Measure the actual quilt to determine the border lengths, using the calculated lengths as a guide.

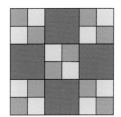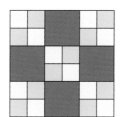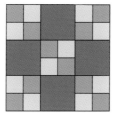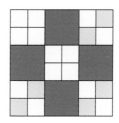

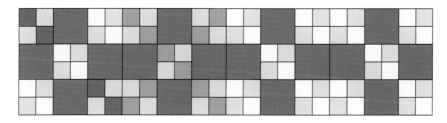

Finishing

1. Sew widths of backing fabric together. Then layer the backing and batting under the top, and baste or pin as needed. Quilt as desired.

2. Cut 3″ straight strips from the red gingham fabric. Sew the strips together until the binding strip measures 167″. Starting at the bottom of the quilt, attach the binding, following your preferred method. Use a ⅜″ seam allowance.

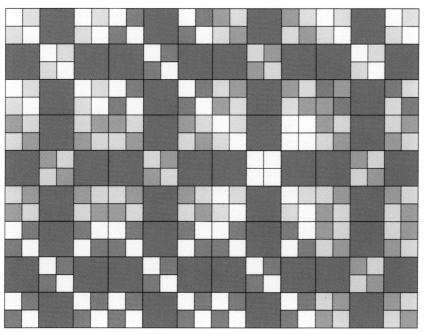

Quilt assembly

NOTES

[1] Office of the Historian (United States Department of State), "Louisiana Purchase, 1803," *Office of the Historian*, https://history.state.gov/milestones/1801-1829/louisiana-purchase (accessed April 29, 2016).

[2] ushistory.org, "Westward Expansion: The Louisiana Purchase," *U.S. History Online Textbook*, http://www.ushistory.org/us/20c.asp (accessed April 29, 2016).

[3] Merrill J. Mattes, *The Great Platte River Road* (Lincoln: Nebraska Historical Society, 1969), 4.

[4] Ibid., 8.

[5] Ibid., 22.

[6] Ibid., 22.

[7] Ibid., 22.

[8] Ibid., 5: 615. Mattes identified the location of more than 2,082 diaries in various forms. State historical societies as well as libraries are great sources for unpublished primary-source diaries.

[9] Katherine Harris, *Long Vistas: Women and Families on Colorado Homesteads* (Niwot: University Press of Colorado, 1993), 85.

[10] Kenneth L. Holmes, ed., *Covered Wagon Women: Diaries and Letters from the Western Trails, 1840–1849*, vol. 1 (Lincoln, NE: Bison Books, 1995), 1:213–14.

[11] Sandra Dallas with Nanette Simonds, *The Quilt that Walked to Golden* (Elmhurst, IL: Breckling Press, 2004), 21, 27.

[12] Holmes, ed., 1:213–14.

[13] Welborn Beeson, *Welborn Beeson on the Oregon Trail in 1853* (Medford, OR: Smith, Smith and Smith Publishing, 1986), 27.

[14] Dallas, 19.

[15] Holmes, ed., 1:216–17.

[16] Dallas, 23.

[17] Linda Peavy and Ursula Smith, *The Gold Rush Widows of Little Falls* (St. Paul: Minnesota Historical Society Press, 1990), 161.

[18] Susan G. Butruille, *Women's Voices from the Oregon Trail*, 2nd ed. (Boise, ID: Tamarack Books, 1994), 100.

[19] Dallas, 25.

[20] Glenda Riley and Richard W. Etulain, eds., *By Grit & Grace: Eleven Women Who Shaped the American West* (Golden, CO: Fulcrum Publishing, 1997).

[21] Dallas, 35.

[22] Chestina Bowker Allen, "Sketches and Journal, 1854–1870," Manuscripts Department, Kansas Historical Society: diary entry March 26, 1854, http://www.kshs.org/publicat/history/1986summer_riley.pdf (accessed January 26, 2016).

[23] Barbara Brackman, "Quilts on the Kansas Frontier," *Kansas History* 13, no. 1 (Spring 1990): 13.

[24] Ibid., 13.

[25] To learn more about quilt names associated with the plains, see *Quilt Kansas!: Patterns* by Jean Mitchell (Mitchell; dist. Lawrence: Helen Foresman Spencer Museum of Art, University of Kansas, 1978) and *The Seasons Sewn* by Ann Whitford Paul, with illustrations by Michael McCurdy (San Diego, CA: Browndeer Press, 1996) as well as individual diaries.

[26] Brackman, 15.

[27] *Atchison Daily Globe*, August 21, 1960.

[28] Ancestry.com. "U.S., Appointments of U.S. Postmasters, 1832-1971" [database] (Provo, UT: Ancestry.com Operations, Inc., 2010), http://search.ancestry.com/search/db.aspx?dbid=1932 (accessed January 26, 2016).

[29] 1900 United States Federal Census, Oregon, Union, Pine, District 0122.

[30] 1905 United States Federal Census, Kansas, Montgomery Co, Coffeyville, Ward 5.

[31] Brackman, 20.

[32] Ann Whitford Paul and Michael McCurdy, *The Seasons Sewn* (San Diego, CA: Browndeer Press, 1996).

[33] Merikay Waldvogel, e-mail correspondence about nineteenth-century Southern quilts, April 27, 2016.

ABOUT THE AUTHORS

Kay Triplett is curator for Quilt and Textile Collections, a company that manages the Poos Collection—one of the largest privately held quilt and textile collections in the world. Although the collection was named to honor her grandmother, Kay is the collector and creator of the collection. She rescued her first quilt on a family picnic as a child in elementary school. From there the collection was enhanced during more than four decades of searching out textiles in Europe, Asia, Africa, and the Americas.

As her collection grew, Kay's knowledge of historic textiles deepened, which led to extensive research with an emphasis on pre–nineteenth-century quilts and textiles. She is a longtime member of the American Quilt Study Group, in which she shares her knowledge with other quilt historians. Additionally, she participates in the Quilt Study program, reproducing or creating quilts inspired by historic quilts.

Kay is a frequent writer for the quilt magazine *Quiltmania*, with more articles on the way. Her first book, *Red and Green Quilts from the Poos Collection*, continues to be a best seller. Her second book, *Chintz Quilts from the Poos Collection*, was cowritten with Lori Lee Triplett and Xenia Cord, and her third book, *Indigo Quilts* (written with her sister), covers the history of indigo from Africa to America. *Indigo Quilts* received the Lucy Hilty Research Grant and the Meredith Scholar Award.

Lori Lee Triplett, the business manager for Quilt and Textile Collections, has successfully combined a variety of passions, including research, writing, and performing, into the quilt world. As a lecturer and instructor, she brings her experience from stage, screen, and radio to make presentations fun yet educational. Depending on which program she is performing, you may meet one of her guests from abroad, sing along with a song, or even participate in solving a mystery. She enjoys presenting at local quilt guilds but also presents at national conferences and has made appearances internationally.

An award-winning writer, Lori has written more than fourteen books and numerous magazine articles. *Indigo Quilts*, her most recent book (written with her sister, Kay), covers the history of indigo from Africa to America. It has received the Lucy Hilty Research Grant and the Meredith Scholar Award.

The successful book *Chintz Quilts from the Poos Collection*, launched in the fall of 2013, was cowritten by Lori with Kay Triplett and Xenia Cord. Lori is a frequent writer for numerous quilt magazines and journals, with more articles on the way. She is a member of the American Quilt Study Group, American Quilter's Society, National Quilt Museum, Heartland Quilt Network, and International Quilt Study Center & Museum. She is a graduate of the University of Arkansas, with a bachelor of arts degree with honors, and a master of arts degree from the University of Missouri-Kansas City (UMKC) Theatre Department. Additionally, she has law degree from UMKC School of Law, where she received multiple awards.

Want even more creative content?

Make it, snap it, share it *using* *#ctpublishing*